IN THE SPIRIT OF WETLANDS

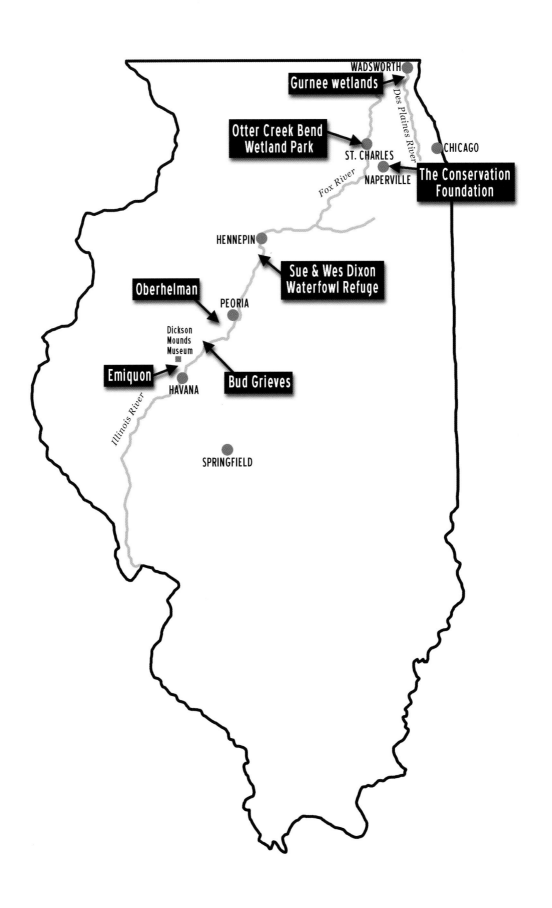

WADSWORTH

Gurnee wetlands

Des Plaines River

Otter Creek Bend
Wetland Park

ST. CHARLES

CHICAGO

NAPERVILLE

The Conservation
Foundation

Fox River

HENNEPIN

Sue & Wes Dixon
Waterfowl Refuge

Oberhelman

PEORIA

Dickson
Mounds
Museum

Emiquon

Bud Grieves

HAVANA

Illinois River

SPRINGFIELD

IN THE SPIRIT OF WETLANDS

REVIVING HABITAT IN THE ILLINOIS RIVER WATERSHED

Text by
CLARE HOWARD

Photographs by
DAVID ZALAZNIK

3 FIELDS BOOKS
An imprint of the University of Illinois Press
URBANA • CHICAGO • SPRINGFIELD

3 Fields Books is an imprint of the University of Illinois Press.

Manufactured in the United States of America
P 5 4 3 2 1
⬯ This book is printed on acid-free paper.

Library of Congress Cataloging-in-Publication Data
Names: Howard, Clare (Journalist), author. | Zalaznik, David, author.
Title: In the spirit of wetlands: reviving habitat in the Illinois river
 watershed / text by Clare Howard; photographs by David Zalaznik.
Description: Urbana: University of Illinois Press, [2022]
Identifiers: LCCN 2021061666 (print) | LCCN 2021061667 (ebook) |
 ISBN 9780252086625 (paperback) | ISBN 9780252053559 (ebook)
Subjects: LCSH: Wetland restoration—Illinois River Watershed. |
 Watershed restoration—Illinois River Watershed. | Wetland biodiversity
 conservation—Illinois River Watershed. | Illinois River Watershed—
 Environmental conditions. | BISAC: NATURE / Environmental
 Conservation & Protection | NATURE / Ecosystems & Habitats /
 General
Classification: LCC QH105.I3 H69 2022 (print) | LCC QH105.I3 (ebook) |
 DDC 333.91/8153097735—dc23/eng/20220111
LC record available at https://lccn.loc.gov/2021061666
LC ebook record available at https://lccn.loc.gov/2021061667

To our parents who believed in looking at problems from new perspectives in order to see new solutions.

For hundreds of years, people generally thought of swamps, bogs, marshes, and moors as unproductive land—even menacing and foreboding land. When industrious developers and farmers virtually exterminated wetlands with dikes, drainage, pumps, and chemicals, few advocates protested because there was no understanding anything of value was being destroyed.

But as evidence accumulated about the essential role of wetlands in the environment, some people became captivated with this vision and undertook a challenge—attempting to resuscitate these backwaters. In many cases, it was trial and error, learning by failure, frustration, and persistence.

Then the forgiving and enduring nature of wetlands responded, and they began to re-emerge. Seeds dormant for a hundred years germinated.

Some restored wetlands are visual feasts, with water stretching to the horizon like a vast inland sea. Some are shy, almost invisible, hiding among tall grasses.

Just as each wetland has its own personality, so do the people who have worked for decades restoring them and helping them once again resume their essential role in the natural world. *In the Spirit of Wetlands* recounts the tales of these restorers and the reemergence of the wetlands they love.

These restored wetlands now have step-siblings: constructed wetlands. This book also engages with these creators—people who construct wetlands where none existed before, and, almost miraculously, the spirit of wetlands emerges on these sites as well.

University of Illinois Press
Fall 2021

CONTENTS

Preface ix
Introduction 1

1 ELIIDA LAKOTA AND MICHAEL WIANT 5
"I am in the river. The river is in me. The river is me."

2 SUE AND WES DIXON 11
Sovereign Republic of the Goldeneye

3 BUD GRIEVES 27
A River Runs Through His Life

4 JOHN RYAN 38
Banking on Wetlands

5 MAYOR KRISTINA KOVARIK 47
Watching, Waiting, and Worrying

6 DONALD HEY 53
The Riverine National Park System Financed by Nutrient Farming

7 DOUG BLODGETT 59
A Huge Cattle Feedlot Becomes an Internationally Acclaimed Wetland

8 DOUG AND DIANE OBERHELMAN 69
From "Hell With the Fires Put Out" to Quail Lakes Wetland Sanctuary

9 JOHN FRANKLIN AND JIM FULTON 76
Invisible Harvest

10 MIKE MILLER AND JIM KLEINWACHTER 89
An Army of Wetland Advocates

Epilogue 95
Glossary 97

PREFACE

Restored wetlands are like people. Each one has its own character and personality. Some stretch magnificently from horizon to horizon. Some hide among grass and timber. Some are most splendid shimmering in moonlight; some find their splendor in the long shadows of a setting sun. There is a mist that rises from wetlands on cool evenings late in summer and shrouds the landscape in mystery.

Some wetlands are so overtly beautiful they elicit spontaneous proclamations of awe, but some are so quiet and unpretentious they are mistaken for fields of weeds.

All the wetlands featured in this book reflect the magic, dedication, study, and hard work of the people who restored them. There is a bond between these people and their wetlands. One wetland creator has told his wife that when he dies, he wants some of his ashes scattered on his first wetland project.

One restorer of wetlands often finds his work takes him hours from his home base, but at the end of a trip, he likes to stop by one particular restored wetland near his house. They reconnect like old friends. He likes to look out over the wetland and reflect that this is his legacy just as surely as his children and grandchildren.

The people featured in this book embody the spirit of wetlands.

IN THE SPIRIT OF WETLANDS

INTRODUCTION

For hundreds of years, people generally thought of swamps, bogs, marshes, and moors as unproductive land. The moors of England have a menacing, foreboding connotation. Unproductive land covered with native grasses and forbs looks messy and undervalued to an uninformed eye compared with weed-free fields of row crop production. The first looks lazy; the second looks industrious. What if we flip that perception? By transforming that thinking, we learn to understand wetlands as productive, restorative, sustaining, mitigating, nurturing, and beautiful. The benefit of wetland restoration is not measured in a conventional bank statement but in a society's sustainability and well-being.

It's impossible not to anthropomorphize a restored wetland and feel overwhelmed by its kindness. Agriculture and development can kill wetlands by draining them, diking them, saturating them with chemicals, and building over them. Yet even a century after that destruction, when a wetland restorer comes along and starts undoing the past, the forgiving spirit of a wetland emerges. Seeds dormant for one hundred years begin to sprout. Water slowly returns to ancient channels. Insects and waterfowl recognize the transformation and return. Vegetation and soils work their alchemy and resume their role filtering and cleaning toxins from the water.

It is this transformative power of wetlands that triggered a passion in the people featured in this book. These people have come to understand wetlands in a way that has changed their view of the environment and, in turn, their view of the world.

Their understanding is hard to quantify and define because it is personalized and unique. It evolved over decades of observing, studying, hiking, moving dirt, planting seeds, and feeling the life pulse of rivers and streams, bogs and seeps. In every case, these are people still listening and learning from the lessons wetlands

patiently teach. These are people who understand wetlands hold answers to questions not yet asked.

In one case, understanding came with the radical decision to sell ownership in a fourth-generation global family business and start a new company based on a yet-untested theory about wetlands. In another case, it came from watching the agony of people flooded out of their homes year after year and embracing the cost-benefit analysis of wetland restoration. For one person, understanding evolved over seventy years of duck hunting and observing the ever-diminishing migration. Still, others purchased marginal farmland and enrolled it in the U.S. Department of Agriculture's Conservation Reserve Program. By taking land out of agricultural production, landowners receive an annual payment from the government. One person who has worked on wetland restorations for decades now has a grand vision, and he meets with politicians and landowners seeking support by sharing his perspectives.

Included among this cadre of people listening to wetlands is a former CEO of a Fortune 500 company, a Native American art therapist, a former financial adviser, two mayors, a waterfowl hunter, scientists, and environmentalists.

Eliida Lakota, a Native American Lakota Sioux, lives by her values in a contemporary world and views wetlands in terms of the philosophy of her culture: What is the impact of her actions today on the seventh generation after her? That necessitates making contemporary decisions based on information not yet known. That's something of a conundrum for the modern mind: deferring action because there is no clear understanding of unforeseen consequences seven generations hence. In contrast to seventh-generation thinking is reductionist thinking that evaluates decisions based on the limited knowledge of the here and now.

The notion of productivity is often based on reductionist thinking: An acre of farmland sitting on top of fields dissected with drainage tiles can produce corn selling for four dollars a bushel. The cost of installing drainage and the cost of getting water off the land as fast and efficiently as possible might produce flooding downstream and exacerbate chemical runoff, but corn still sells for four dollars a bushel.

The cost of dealing with flooding is now the largest environmental expense depleting our national resources—more than Medicaid, Medicare, Social Security, or public education.

Learning about wetlands changes thinking about productivity versus conservation; in fact, conservation may be the ultimate in productivity. In the case of wetlands, what once might have been viewed as unproductive land becomes the restorative life pulse of an ecosystem.

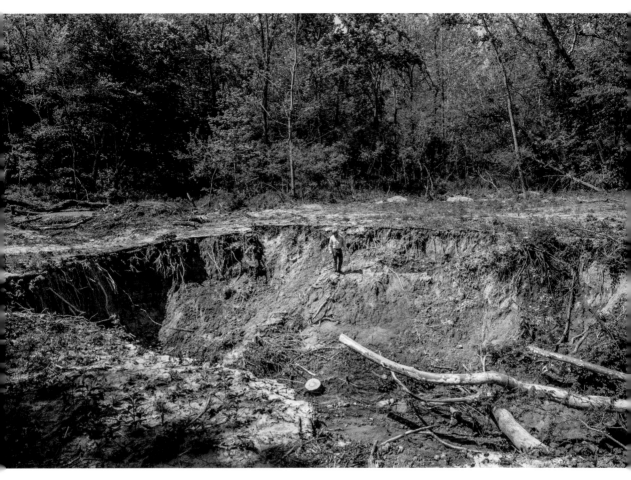

Photo 0.1. Mike Miller steps through a crevasse in Forest Park Nature Center in Peoria. Heavy rains resulted in water runoff from the bluffs above through the valley. Decades-old erosion control structures proved incapable of handling the water's velocity.

Mike Miller has worked in the field of nature interpretation for over thirty years and says there is no easy answer for how to expand our vision to embrace natural solutions.

"In this age of fast information, you'd think we'd find solutions, but it seems people only seek the information that strengthens their biases," he said. "The change happens when people experience an epiphany. It might be with birds or insects or fish or finding solace in a natural area. That epiphany expands and triggers an altered view of the world."

He understands that change can also happen without an epiphany. It can build and emerge slowly over years and decades of work, observation, and reflection.

Ask Miller if wetland conservation and restoration is an art or a science, and he responds it is both.

"There is a certain amount of engineering with levees and dikes. There is the vegetative component. And then there is the aesthetic," he said, quoting Aldo Leopold, who wrote preservation and restoration must include three elements: integrity, stability, and beauty.

When looking at a $250,000 erosion control system that was mostly concrete, Miller said, "The project manager was looking at this erosion problem with his engineering brain. We look at this problem with our environmental brain. Sometimes, a little poetry and philosophy are needed to understand a problem and develop a sustainable solution."

When a problem has a clearly defined cause and a cost-effective, aesthetically pleasing solution, why is it not more widely embraced? Perhaps one reason is because neither the problem nor the solution is understood. Restored and constructed wetlands provide long-term carbon sequestration—critically important as climate change accelerates. The people featured in this book each share their vision of the problem and their vision of a solution with the hope we all experience an altered view of the world.

"If you are unable to understand the cause of a problem, it is impossible to solve it," said Naoto Kan, a former prime minister of Japan.

1

ELIIDA LAKOTA AND MICHAEL WIANT

"I am in the river. The river is in me. The river is me."

For decades, Eliida Lakota sprinted along the shore of the Illinois River each morning at dawn with her Chesapeake retriever named River. The two would race along the shoreline as boats and barges passed by, and they'd watch the sunrise. She'd run through rolling fog, cascading autumn leaves, and gentle snows.

"The Lakota people were great runners, and I loved to run and feel the way it made my body feel," she said.

"Mother Earth" and "Father Sky" reflect Lakota's Native American heritage. She often sensed her mother, long dead, as a great blue heron flying slowly above her on these solitary runs along the river.

Now at seventy-six, Lakota isn't running, but her connection with the pulse of the river is like a heartbeat.

That exemplifies eutierria—the blending of self and environment, an almost meditative state of losing sense of self and becoming part of the surrounding environment.

"I am in the river. The river is in me. The river is me," Lakota said.

Her worldview and reverence for nature are informed by her culture. Her father was Lakota. Her mother was Yakima. A grandmother was Shawnee. She is grounded

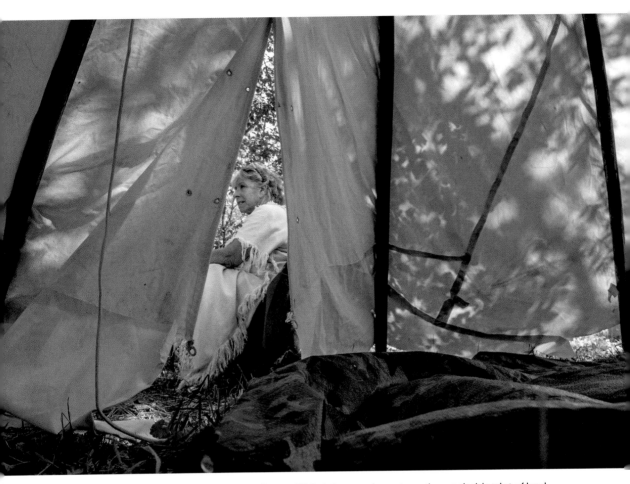

Photo 1.1. The entrance to her tepee frames Eliida Lakota as she rests on the creek-side plot of land she owns in Peoria County. The tepee is a part of her Native American heritage she cherishes and that informs her love for the land and water.

in "seventh generation thinking" and uses that metric to evaluate any action from cutting a tree to diking the river or draining a wetland. She questions, how would this action affect the seventh generation after me?

The answer creates a complicated and beautiful web of her life that triggers everything from resuscitating a spider that nearly drowned in her bathtub to blessing her tepee poles and sleeping alongside the river. Her perspective on life reflects her self-transcendent values.

As an infant, she and her parents lived in a cabin on Lake Michigan. They later moved to central Illinois along the Sangamon River. Nearly sixty years ago,

she bought a tiny house near the Illinois River and owns four acres along Kickapoo Creek, a tributary of the river.

She retired after decades of work as an art therapist in hospitals, using art as a way to enable people to communicate nonverbally. She still leads art workshops and relies on the landscape inside her to help patients connect with the natural world and express feelings that can be cathartic.

Though she lives in the modern world and she owns land, her land stewardship is unlike her neighbors.

"Native American people did not own land. When Europeans came to this country, they brought fences and the concept of land ownership and land productivity," she said. "They valued land based on their own needs and what land could do for them. If nature was not serving their own purposes, they viewed it as useless. But everything is not created for man's benefit."

Lakota's house is surrounded by a yard converted into a nature preserve. When someone pointed out a "perfect lawn" across the street she said, "How can that be a perfect lawn? What is there for birds to eat and bees to pollinate?"

Her land is a no-kill zone: No killing spiders, snakes, mice, bats, voles, chipmunks. No herbicides. No insecticides. She notices individual spiders, individual snakes. She recognizes which plants seed and send offspring far and wide. She does not "weed" in the conventional sense of digging up and disposing. She might dig up those wandering offspring, shake off the dirt from their roots, and replant them closer to their parental home.

Over the years, she watched as the beloved sycamore tree in her yard grew from eight inches in diameter to four feet. When it was hit by lightning, she called an arborist and was told to cut the tree down. She wrapped her arms around the tree and cried, pledging they would remain together, and she would learn from the strength and grace the sycamore brought to the process of death. As tree limbs died and were removed, her garden adapted from shade to mottled sun. Even in death, the tree remains integral to her life and the life of her garden. There is no concept of forgetting it, clearing it out, or replacing it. Death does not end their relationship.

Lakota shudders at the idea of cutting down trees for Christmas. "Sacrilegious," she calls it. "I go into the woods when I feel the need to decorate a tree."

The concept of cutting trees or draining wetlands wounds her.

Her path crossed with Michael Wiant in 2003 when he became director of Dickson Mounds State Museum, located on a Native American settlement and burial

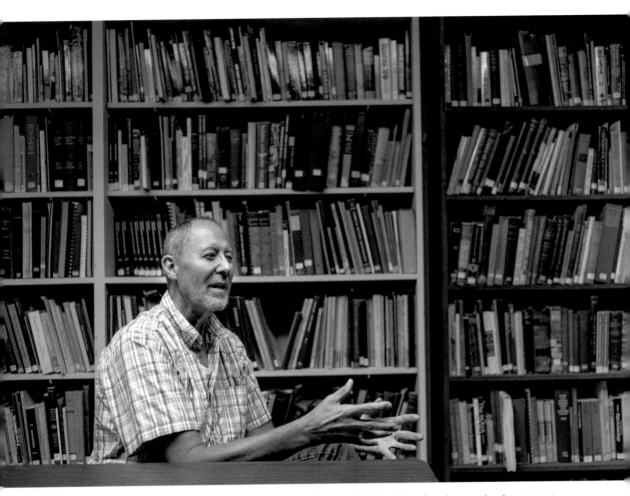

Photo 1.2. "I can stand at the banks of the Illinois River with Eliida [Lakota] and recognize the concept of Mother Earth. I can celebrate Earth's role as the centerpiece of life and recognize that the loss of that resource has profound consequences," said Michael Wiant, former director of Dickson Mounds Museum, anthropologist, archeologist, and environmentalist.

ground on a bluff overlooking the Illinois River. The museum is on a rich Native American archeological site south of Peoria.

Wiant can pinpoint a pivotal time when his view of the world shifted. He was an archaeologist prior to 2003 and had taught anthropology and museum studies at Illinois State University for twenty-seven years. He was secure in his academic discipline and his perspective on the world.

Then, he and Lakota met and developed a long-term friendship that has changed them both. They are friends, mentors, disciples, and collaborators—each explaining

to the other and learning from the other. Over the years, his perception of nature has expanded to understand more of her metaphysical and spiritual beliefs.

Today, Wiant considers himself an environmental anthropologist. Connections, consequences, and responsibility are foundational to his global assessment and understanding of wetlands.

"I can stand on the banks of the Illinois River with Eliida and recognize the concept of Mother Earth. I can celebrate Earth's role as the centerpiece of life and recognize that the loss of that resource has profound consequences. Being connected to Earth reminds us to be conscious of consequences," he said.

When explaining the creation of wetlands in central Illinois, Wiant cites the great Kankakee Torrent that occurred 20,000 years ago when an ice dam burst and sent a tsunami of ice, water, and stones sweeping down the river, scouring out an expansive floodplain. That event altered the velocity of the river and created a terrain pocketed with seasonal backwater lakes and wetlands.

Wiant links ancient wisdom to that wetland environment. In the rich backwaters of the Illinois River, Native American villages flourished. Abundant food gave life stability.

"The roots of a sedentary life were related to the use of aquatic resources in the backwater lakes. Sedentary communities became large, and people lived longer. The elderly were able to share guidance and values. There is an abundance of evidence that wisdom is a form of social organization," he said. "The nomadic life is more uncertain."

Once there was a necklace of wetlands up and down the Illinois River that provided a rich and fertile environment—"an ecological powerhouse"—for Native American people. Those wetlands provided the stability and sustenance Wiant links with the development of reflective wisdom.

But instead of seeing abundance, early European explorers lamented the upper Illinois River was not navigable. The river was assessed as an economic tool that could provide an aquatic route for trade. By the 1870s, construction began on locks and dams that destroyed the seasonal waxing and waning of wetland water levels.

In the early 1900s, associations called water districts were formed on land along the river. Farmers joined districts for the purpose of diking out the river, draining swamps, and converting land to row crop cultivation. Pumps ran twenty-four hours a day, year-round. Member farmers shared in the costs and reaped the harvests. The once-great migration of waterfowl and abundance of aquatic life disappeared from the landscape. This was accepted as part of the price for progress.

"It's an incredible example of a system started to impede the natural flow of the river," Wiant said. "It's an example of not being attentive to nature. Native people adapted to the rhythms of nature. Today, people try to force nature to adapt to us. We fail to understand the interdependence of human activities and the environment."

That failure is manifested with increasing floods, wildfires, rising sea levels, increasing atmospheric carbon, polluted water and air, and global climate change.

"It's immoral when we alter the environment and knowingly allow negative consequences to affect human beings," Wiant said.

Now retired and in his seventies, he's on a quest with a stopwatch in hand.

"The horizons of knowledge are so much vaster today. My academic studies have expanded," he said. "There is no coasting anymore. We have a new sense of urgency. We've got to accelerate the pace of learning, take off the blinders, and understand the consequences of our actions."

2

SUE AND WES DIXON

Sovereign Republic of the Goldeneye

The Sue and Wes Dixon Waterfowl Refuge is a Sleeping Beauty saga.

Like the classic Grimm's fairy tale, this story recounts a beautiful and implausible awakening after a deep slumber of one hundred years.

Once, the seasonal pulse of the Illinois River ebbed and flowed through this marsh near Hennepin, creating a rich habitat for prairie and wetland vegetation, fish, and wildlife. There was life in abundance in all seasons, diurnal and nocturnal.

But eyes that saw beauty and value only in row crop production, bushels per acre, and commodity prices facilitated the widespread destruction of wetlands.

The steel plow and a new concept that allowed farmers to band together into an association called a water district to dike, drain, and operate pumps year-round resulted in the near elimination of wetlands and the native vegetation and wildlife that thrive on marshy swampland.

The pumps began here in the early 1900s; corn and soybeans were planted on this rich bottomland hugging the Illinois River. After World War II, when agricultural chemicals began to gain popularity, the land was doused in herbicides and insecticides. The technologies of chemical warfare seamlessly transferred from the battlefield to the farm field—making it even more implausible any vestiges of that former life could survive.

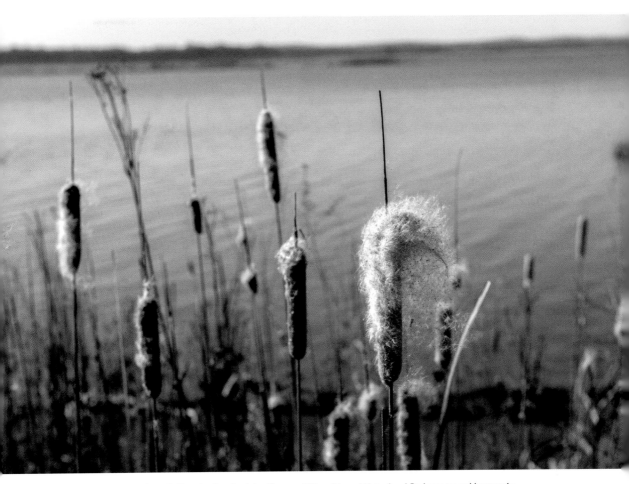

Photo 2.1. Cattails line the bank of the Sue and Wes Dixon Waterfowl Refuge near Hennepin.

What started profitably in the early 1900s began to change, and by 2000, costs were beginning to outpace profits.

But a group from Chicago perceived beauty here. They were with a Chicago not-for-profit organization looking for land for restoration, research, and recreation.

Negotiations with nine landowners went astoundingly well, and the Wetlands Initiative purchased the Hennepin and Hopper property and hired Rick Seibert, the man who had maintained the pumps for decades.

Seibert became site superintendent, and when he turned off the pumps in 2001, a remarkable transformation began in both the man and the land.

But no passionate kiss from a prince instantly awoke the Sleeping Beauty in this saga. It was cold, hard science applied passionately and tirelessly over decades, sometimes by trial and error pioneering new methods of wetland restoration.

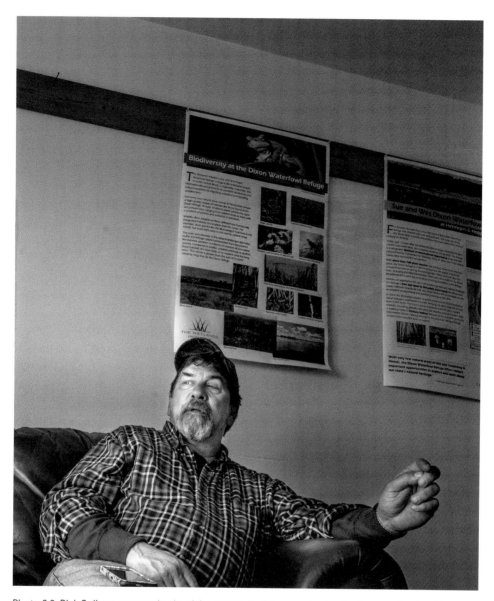

Photo 2.2. Rick Seibert once maintained the pumps that drew water levels down on farmland. In 2001, the pumps were turned off, and the site became the Sue and Wes Dixon Waterfowl Refuge. Seibert, now site superintendent at the refuge, admits he has been transformed with the land.

Seibert had worked in the steel mill in Hennepin and had maintained the pumps for the water district on this property. He hunted and fished. On weekends, he was a duck spotter for members of area hunting clubs.

He noticed that almost as soon as water resumed seeping onto this land, seeds that had been dormant began to germinate. Roots that stretched almost twenty feet

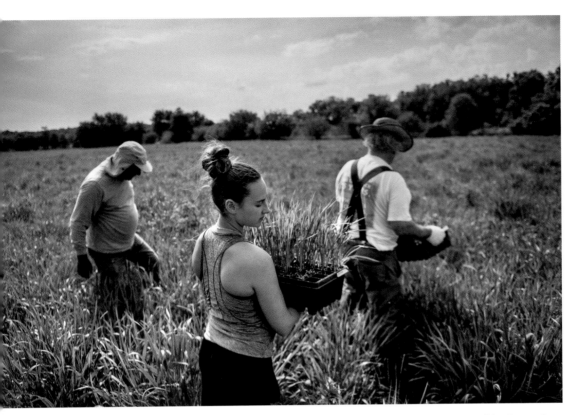

Photo 2.3. Volunteer Faith Glancy carries a box of seedlings at Hickory Hollow, part of the Sue and Wes Dixon Waterfowl Refuge. Glancy and dozens of other volunteers spent hours planting in an effort to restore the farmland to its original glory as an upland prairie and savanna.

Photo 2.4. Joseph Kunkel drills into the dry earth at Hickory Hollow as volunteers follow in his wake planting grassland seedlings.

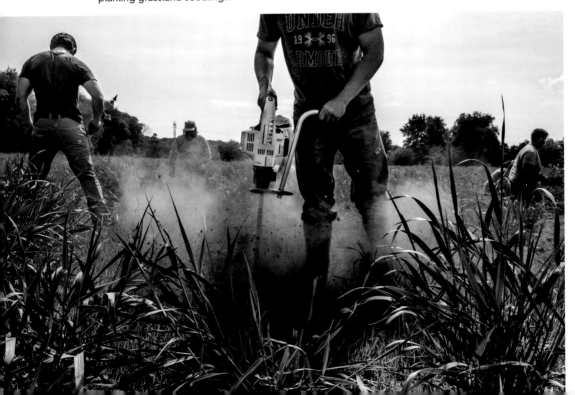

into the earth began to regenerate. The land started remembering its past. Seeps found their old channels.

The staff at the Wetlands Initiative was astounded. And Seibert, who didn't know the difference between big bluestem, yellow monkeyflower, and sago pondweed, was hooked.

The guy who once worked with steel became a botanist of sorts. Today, after two decades of nurturing this wetland, Seibert is still a hunter, but on a recent hunting trip to Idaho with his son and daughter-in-law, he found himself marveling more at the wildflowers and less at the rack on his daughter-in-law's bull elk.

"It has become a real pleasure. Now anywhere I go, I'm always looking at the plants," he said.

Today, all who drive through the stone gates at the end of an unassuming gravel road into the Sue and Wes Dixon Waterfowl Refuge enter a time warp into a wetland terrain dating back thousands of years. There is a sense here of clarity, and beauty engulfs reflective visitors.

Photo 2.5. A prairie burn initiated by site superintendent Rick Seibert helps maintain the plant diversity at Sue and Wes Dixon Waterfowl Refuge.

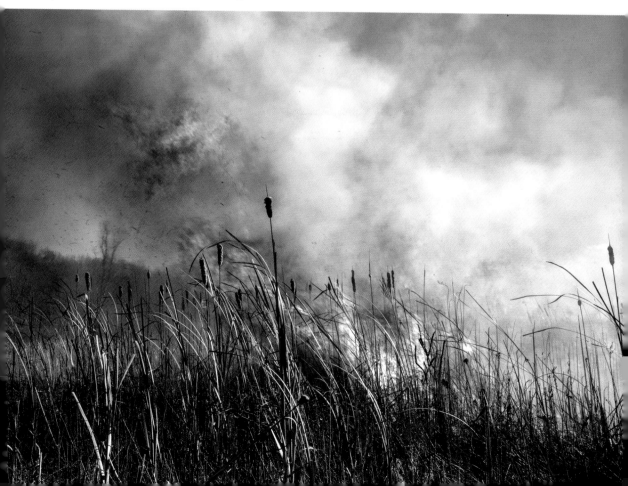

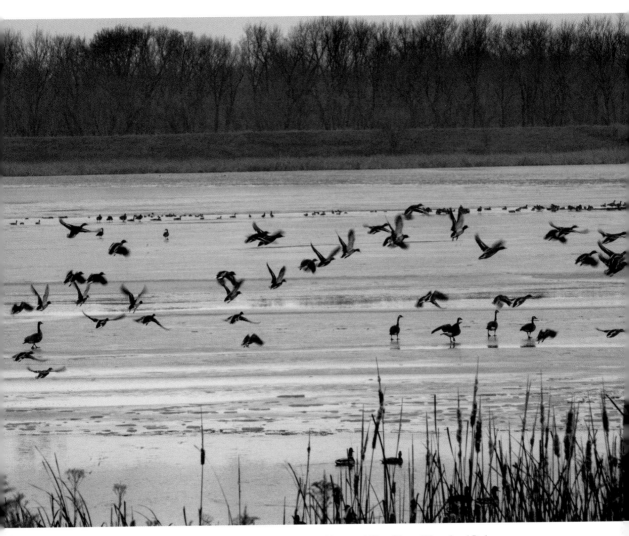

Photo 2.6. Waterfowl take flight over the waters of Sue and Wes Dixon Waterfowl Refuge.

The magic of this place is a magnet for volunteers. They come from area high schools and colleges. Sometimes, vans full of volunteers drive down from universities in the Chicago area.

Manual labor on this 3,000-acre wetland can range from collecting seeds of deep-rooted perennials blanketing the terrain to planting hundreds of shoots grown from seeds collected the previous year.

Once, a group from the University of Chicago worked for hours collecting seeds when an exhausted, young philosophy major threw butterfly milkweed seeds into the

air, proclaimed it aerial ballet, and then danced through a swirl of seeds pirouetting through the air.

Driving from Chicago to the Sue and Wes Dixon Waterfowl Refuge, cars pass massive industrial farm fields with no butterflies, no migrating birds, no pollinating insects.

A short jog off Interstate 80 near Hennepin and this alternative universe opens. It's a sovereign republic of 3,000 acres. Citizens are the goldeneye, canvasback, hooded mergansers and other migrating waterfowl, songbirds, bats, insects, flora, and fauna. Visitors here leave with a new citizenship and new responsibility. Understanding of this place brings a sense of responsibility for this and other wetlands.

Gary Sullivan, senior conservation ecologist at the site, described a day in spring when a group from Chicago arrived at the property and saw more than 10,000 snow geese covering a mile of the lake. Something spooked the geese and they arose en masse, obstructing the sky and sounding like the roar of a jet engine. Everyone stood transfixed, watching a spectacle not seen here in a century.

Photo 2.7. Gary Sullivan, chief conservation ecologist for the Wetlands Initiative, gives a brief tutorial before leading a group of volunteers in planting a reclaimed savanna adjacent to Sue and Wes Dixon Waterfowl Refuge.

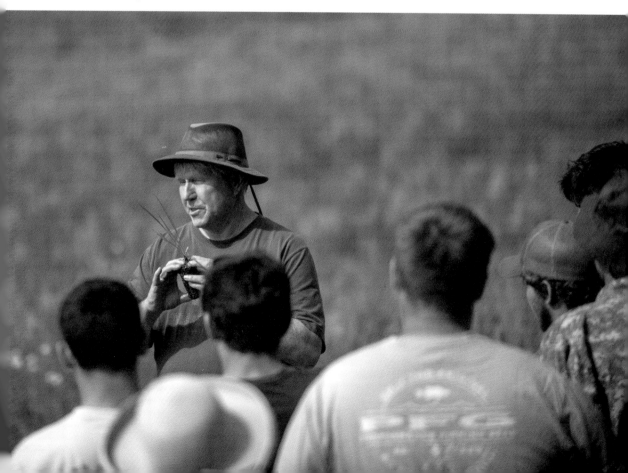

Photo 2.8. Sue Dixon walks to her wetland near her home in a north Chicago suburb. Dixon and her late husband, Wes, were instrumental in the birth of Hennepin and Hopper Lakes near Hennepin. With the Dixons' financial support, thousands of acres of former farmland have been restored to wetlands that once teemed with wildlife and plants.

THE HISTORY

There's more improbable provenance in the transformation of this property. The original scouts from the Wetlands Initiative reached out to Sue and Wes Dixon about the idea of a restoration here. That proved fortuitous.

Sue Dixon grew up in an exclusive suburb of Chicago and hunted big game in some of the most exotic and remote regions of the world. She and her husband went fly fishing in the Upper Peninsula and caught salmon in Alaska. They hunted big game

Photo 2.9. Sue Dixon pauses in her Chicago-area home where she and her late husband, Wes, formulated a plan to find a major environmental cause they could support financially. They found that cause in the Wetlands Initiative and its development of the Hennepin and Hopper Lakes.

throughout the African continent and camped along the Nile River in Sudan. Conditions were often primitive, uncomfortable, and harsh. Dixon was often the only woman, and she loved those trips.

But over her lifetime, the Illinois River never lost its claim on her heart. She witnessed the once-legendary waterfowl migration that swept through the Midwest dwindle sharply over the decades as industry and development spread into flood-plains and ephemeral marshes, draining the land and building over it. The river was treated like a giant sewer.

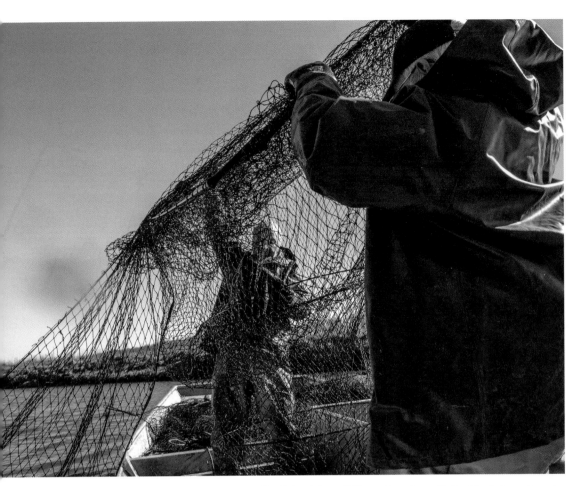

Photo 2.10. Fisheries biologists Ken Clodfelter, left, and Wayne Herndon, with the Illinois Department of Natural Resources, collect fish at Sue and Wes Dixon Waterfowl Refuge near Hennepin. The work involves catching a sampling of fish, weighing, and measuring size as part of a census biologists undertake at the wetland to gauge the health of the population.

Sue Dixon and her husband, Wes, who died in 2014, were invited to tour this particular water district in 2000 with Donald Hey and Al Pyott from the Wetlands Initiative.

To everyone's amazement, Sue Dixon recognized the land. She and her father had passed through on hunting trips more than half a century earlier. She remembers it as an "ugly property with rusty fuel tanks and diked fields of corn and soybeans."

She was still a teenager when she first set eyes on the property. It was only after she had finally passed the marksmanship standards set by her father that he invited her to accompany him on duck hunting trips.

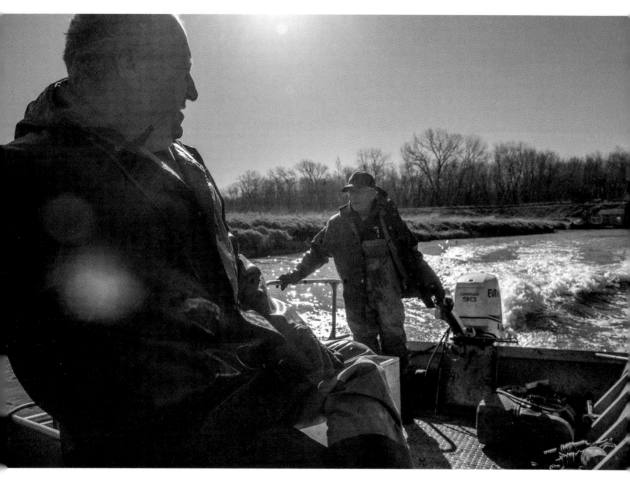

Photo 2.11. Fisheries biologists Ken Clodfelter, left, and Wayne Herndon, with the Illinois Department of Natural Resources, drive their boat through the waters of Sue and Wes Dixon Waterfowl Refuge near Hennepin.

"Duck hunting can be cold and uncomfortable. Not many women went duck hunting then," Dixon recalled.

She and her father would drive down from Lake Forest, park on this "ugly property" hugging the east side of the Illinois River, and motor across the water in a jon boat to property her father owned for duck hunting along the west shore.

It was on those trips she began to love the Illinois River. When she started dating Wes Dixon, he joined these father-daughter hunting trips.

Whether that early connection had any influence on what ultimately unfolded is anyone's guess.

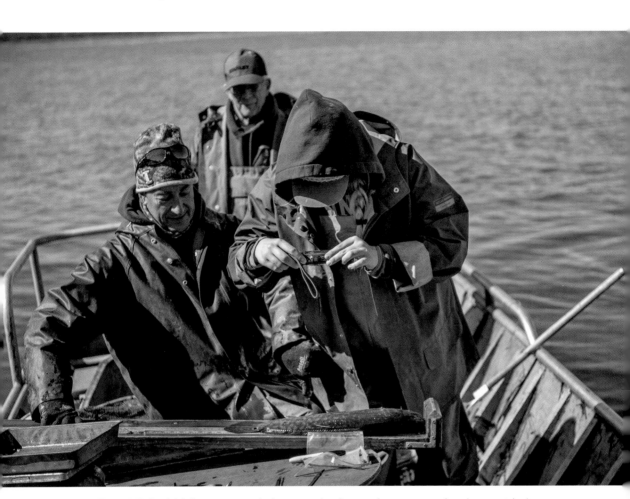

Photo 2.12. Sarah Molinaro, a master's degree student in natural resources and environmental sciences at the University of Illinois, photographs a fish caught at Sue and Wes Dixon Waterfowl Refuge as part of a study to gauge the health of the refuge. With Molinaro in the boat are fisheries biologists Rob Hilsabeck, left, and Wayne Herndon. Hilsabeck is a district fisheries biologist with the Illinois Department of Natural Resources.

The timing was right.

Hey and Pyott of the Wetlands Initiative were looking at this diked farmland with an idea in mind. They envisioned a project. Sue and Wes Dixon had sold the family business, G.D. Searle & Co., to Monsanto. They were looking for a project.

The group toured the property in Jeeps. The land was covered with thistles, cattails, and several garbage dumps.

The couple reviewed an initial proposal and felt it was too limited. It did not match their goals. They asked Hey and Pyott to expand the plans. A new, bolder concept won their support.

Photo 2.13. Sarah Molinaro, a master's degree student in natural resources and environmental sciences at the University of Illinois, records information gathered at Sue and Wes Dixon Waterfowl Refuge as part of a study to gauge the health of the refuge.

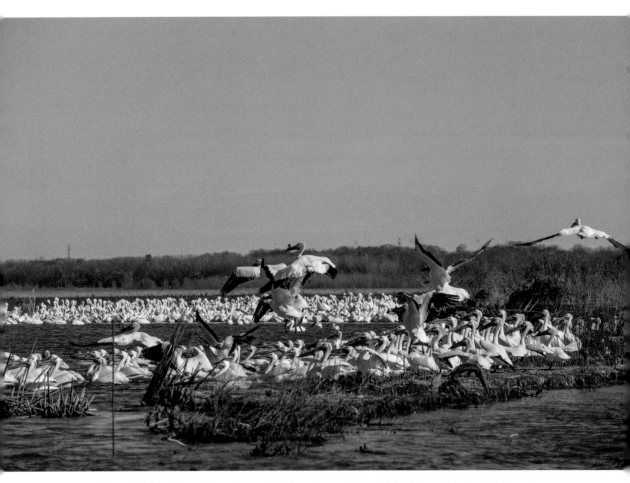

Photo 2.14. American white pelicans glide in to feed at Sue and Wes Dixon Waterfowl Refuge at Hennepin and Hopper Lakes near Hennepin.

The transformation of the property began.

Sullivan said once the pumps were turned off, "It quickly became apparent that underwater aquatic vegetation was coming up in the middle of (former) corn fields. The seeds had been there for one hundred years exposed to herbicides and plowed over, and they were coming back! Sago pondweed is one of two primary species most sought after by migrating waterfowl, and there it was!"

The late Frank Bellrose, a renowned waterfowl specialist, said in his entire life, he'd never seen as much sago pondweed as he saw at this wetland restoration, Sullivan recalled.

Countless migrating birds have found the refuge, including sandhill cranes, canvasback ducks, bald eagles, American white pelicans, coots, and goldeneyes.

Photo 2.15. American white pelicans float in the morning sky above Sue and Wes Dixon Waterfowl Refuge at Hennepin and Hopper Lakes near Hennepin.

"One farmer in his eighties watched a group of canvasbacks and said in his entire life, he had never seen one, and now they migrate through in the thousands," Sullivan said.

Sullivan's land ethic is deeply influenced by Aldo Leopold and Joy Zedler. Essential to the concept is aesthetic beauty. Sullivan calls it "aesthetic magic." That beauty is what draws people back to the site year after year.

He did not initially favor opening the refuge to the public. He was interested in research and restoration. He came to understand the property as a powerful tool to change the way people think about land.

"Once people experience this kind of wilderness, they are moved by it and never view land the same way again. Their thinking changes. They experience something unique and see value where they didn't see it before," he said.

Though many residents of Illinois don't know this property exists, it does not go unnoticed by the goldeneye and other migrating waterfowl.

Sullivan concludes migrating birds are giving the site an A+ rating.

By fall of 2020, 278 species of birds had been identified on the site. Of the twenty-nine species listed as endangered and threatened in Illinois, twenty-three had been observed at the site.

"They are telling us we're doing a good job," Sullivan said.

Another confirmation of a job well done: The Sue and Wes Dixon Waterfowl Refuge is an internationally recognized Ramsar Site, accredited in 2012 by the Ramsar Convention on Wetlands based in Ramsar, Iran. Ramsar was the first modern treaty among nations aimed at halting worldwide loss of wetlands and conserving natural resources.

The Sue and Wes Dixon Waterfowl Refuge is open to the public year-round and is considered one of the world's most significant wetlands.

3

BUD GRIEVES

A River Runs Through His Life

Bud Grieves sat on the deck of his log home as evening stretched into night and the terrain before him slipped into an expanse of darkness unrivaled anywhere in Illinois.

A chorus of tree frogs and cicadas began the evening concert quietly but gradually seemed to reach a deafening, anticipatory crescendo.

Then, at 8:59 P.M. on a Saturday in late July, an orange orb crested over the eastern river bluff. As it rose, the full moon illuminated a panorama fully 180 degrees from north to south over the widest section of the Illinois River valley. The view is seven miles across from bluff to bluff.

Long shadows and silvery streaks of moonlight accentuated the timeless mystery of this landscape. A shelf cloud drifted overhead from the west and infused the night air with the aroma of approaching rain.

Grieves's property was once diked, drained, and planted in neat rows of corn and soybeans fed a rich diet of chemicals. That was once the widely accepted way to efficiently use land. Now the row crops are gone, replaced with a series of wetland lakes, native trees, and prairie plants. The land has been resuscitated with the life pulse of the Illinois River.

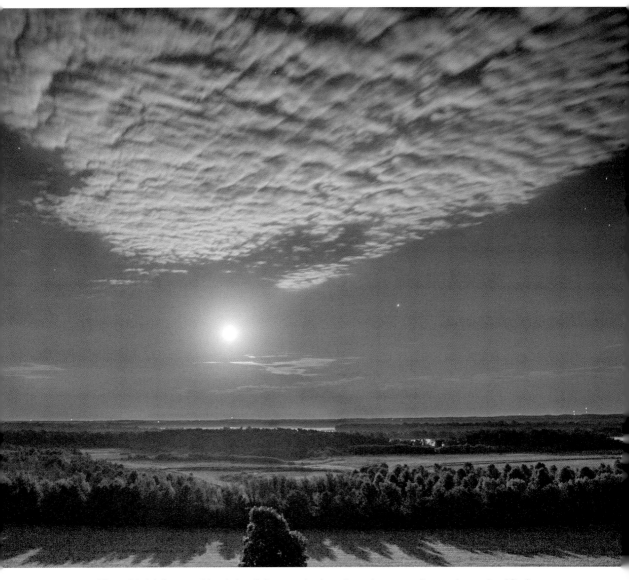

Photo 3.1. A full moon rising in late July casts shadows from the vegetation on the wetland Bud Grieves has restored along the Illinois River near Banner. Once an avid hunter, Grieves now finds as much satisfaction anticipating the seasonal migration of waterfowl.

The amount of work represented here is impossible to quantify. The thinking about what constitutes "productive" land is transformative. Even the name has changed from swampland to wetland. Implicit in the name change is terrain that has resumed its healing, historical role in the environment. Rather than bushels per acre, value is assessed with ecological restoration.

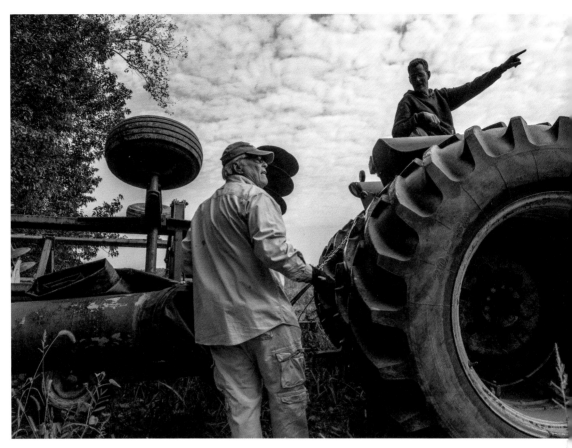

Photo 3.2. Bud Grieves talks to his hired hand about the best approach for the day's work: pumping water from lake-to-lake to maintain the wetland in its seasonal evolution.

This is all part of the magic of wetland restoration. The generosity of wetlands grants absolution even for the sins inherited from surrounding properties. A restored wetland resumes its communal role mitigating floods, purifying water, feeding migratory waterfowl, providing habitat for deer, turkeys, quail, coyotes, muskrats, and foxes.

"Friends ask me why I bought land here rather than north along the river," Grieves said. "I tell them, just look at this view. There's no other place on the Illinois River with this sweeping view."

When schoolchildren and study groups visit his property, he tells them what they are witnessing was formed when a great ice dam broke upriver almost 20,000 years ago, sending a torrent of ice, water, stones, sand, trees, and everything else in its path surging downriver, carving out this great river valley.

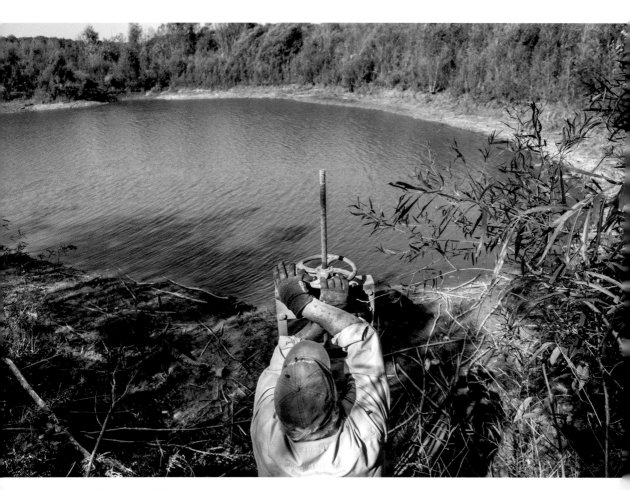

Photo 3.3. Bud Grieves opens a valve to send water from one in a series of wetland lakes to another.

"This is a view Native Americans looked at over 10,000 years ago," Grieves said.

He first saw the view decades earlier when he was crawling under some bushes mushroom hunting. He thought the spot would be a terrific location for a home. He could never have anticipated the work and the thinking that would unfold over the pursuing decades.

A typical workday now starts with Sadie.

Most mornings, Grieves leaves home and "commutes" to his work site in a Polaris Ranger.

"Sadie rides shotgun," he said as he and his four-year-old chocolate Lab walk toward the four-wheeler.

A duck hunter since age eleven, Grieves said, "Now I get greater joy working on the wetlands and anticipating the great migration" of ducks flying south for the winter.

With regal posture, Sadie sits on the front passenger seat. When her joy is uncontrollable, she jumps out of the Polaris and races ahead, periodically glancing over her shoulder to be sure the four-wheeler hasn't veered off onto a divergent path.

What might seem like the most wholesome and iconic American image of man and dog working on the land is now a race of sorts: a race to avert ever-increasing floods, devastating erosion, and total destruction of the historic ecosystem.

Grieves and Sadie spend nearly ten months a year here where Grieves works on restoration projects from a high savanna of ancient oaks to wetlands and floodplain prairies.

"She's one of the luckiest dogs in the world," Grieves said, noting that in summer, Sadie has hundreds of acres for running and half a dozen lakes for swimming. In winter, she stays with the family in Florida and enjoys the pool.

Photo 3.4. Bud Grieves, with the Illinois River valley spread out behind him, speaks at his bluff-top home site to a group from the Bradley University chapter of Osher Lifelong Learning Institute about his efforts developing wetlands in the valley.

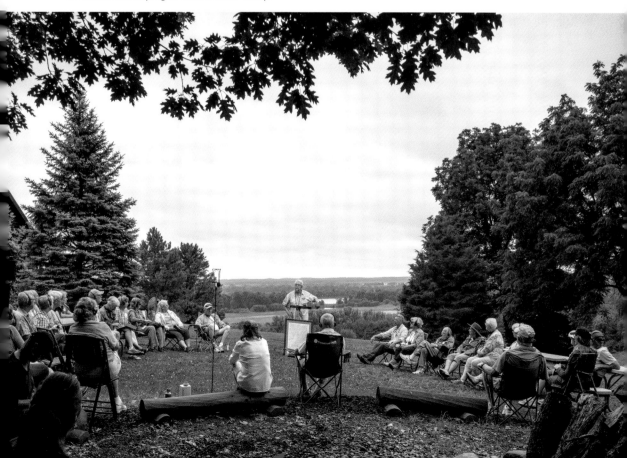

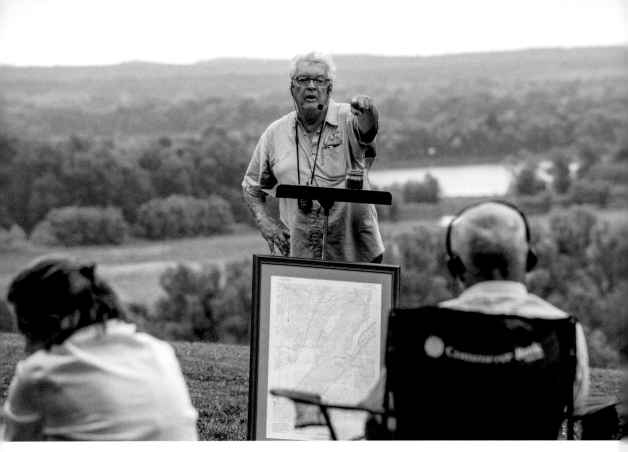

Photo 3.5. Standing before a group from Osher Lifelong Learning Institute, Bud Grieves talks about the history of the river valley that once teemed with life and was home to tribes of Native Americans. He is standing with his back to the Illinois River valley and on a bluff that overlooks the wetland he restored.

Grieves, a rare combination of urban sophistication and country smarts, spent a career as a stockbroker and financial advisor capped by two terms as mayor of Peoria.

The Illinois River runs through his life.

He began his entrepreneurial career when he was eight years old fishing on the riverbank near his family home in Lacon, Illinois. He met and befriended a fellow fisherman who told great stories about the river. The fellow was about eighty years old and showed Grieves his basement filled with crates of coffee grounds and thousands upon thousands of night crawlers.

That was an appealing business model for a young boy. Grieves began paying his two sisters and friends one cent for five night crawlers. By the time the business peaked, he had a workforce of fifteen kids. As he grew, his entrepreneurial empire grew to owning restaurants, a hotel, and a riverboat paddle wheeler, the Spirit of Peoria.

But throughout his life and his career, the Illinois River was a nearly daily presence.

The lure of the river spawned a life-changing adventure; on the first day of summer vacation after his junior year in high school, Grieves and a friend set off on a voyage down the Illinois River to New Orleans piloting a flat-bottom jon boat with a pup tent and a 7½-horsepower Mercury engine.

He's still amazed to this day he was able to convince his parents to allow the adventure.

"The engine was underpowered for the Mississippi River," Grieves said as he recounted the trip.

Photo 3.6. Sitting in his all-terrain vehicle he uses to traverse his wetland, Bud Grieves explains his process for recreating the pulse of the river that allows his wetland to thrive.

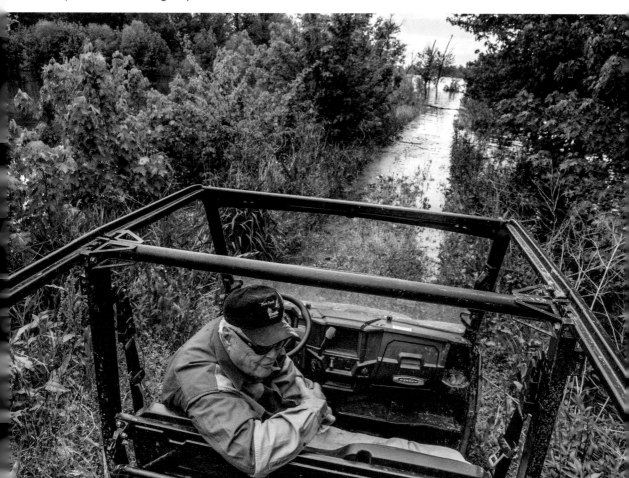

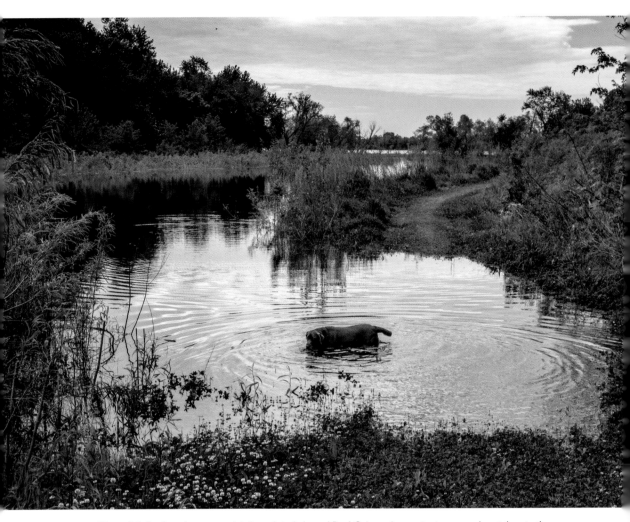

Photo 3.7. Sadie, a four-year-old chocolate Lab and Bud Grieves's constant companion, takes to the water in the 136-acre series of wetlands Grieves has developed.

The year was 1961, and he went from a fairly homogenous upbringing in Lacon to experiencing all the diversity the United States had to offer.

"We saw everyone on the river," Grieves said. "But when we hit the Mississippi below Memphis, we miscalculated how huge the levees were, and sometimes, we missed towns altogether."

Those levees made an impression on him because of the ugliness of massive engineering efforts to contain the river. Half a century later, his work to contain and mitigate flooding is based on a combination of aesthetics, engineering, botany, and hydrology.

He recalls one incident on their trip down the Mississippi when they missed seeing a town altogether where they had planned to buy gas. Their engine died, but the two boys managed to pull the boat to shore, tied it up, and started walking down a road with two empty five-gallon cans. They saw a dust cloud over the horizon and watched as a car approached them. It was filled with African American kids who asked what they were doing.

"They listened to our situation and told us to hop in, and they'd drive us to town," Grieves said, recalling the town consisted of about five unpainted buildings and a church. "They told us they'd give us the gas, but we had to go to church with them. After church, we ate with them. Chicken and pie—a meal better than we'd had in weeks."

In the ensuing years, it would be these poor Southern towns along the Mississippi River that would be repeatedly destroyed by floods that only increase from decade to decade.

The kids from this small town drove the two Lacon boys back to their boat, and their voyage continued. They ended their journey at Lake Pontchartrain, sold the boat, and Grieves's father wired them money for bus tickets home.

The bus pulled into Jackson, Mississippi, about 11 p.m. into the middle of an angry mob demonstrating against white Freedom Riders.

"We were these two white kids sitting on the bus. Luckily, the bus driver slowed down, saw what was happening, and never stopped," Grieves said. "I still remember the hate in the eyes of people outside the bus yelling at us.

"That six-week trip changed me as a person. I saw more of the world and understood more."

Back in Lacon, his family had owned a woolen mill. He recalls seeing a pipe from the dye house discharging directly into the Illinois River.

"The river is a lot cleaner today than it was when I was growing up, but we have not done enough to stop siltation and flooding," he said, noting that farmers today can work on bottomland, take a meandering stream and cut it into a straight channel, lay drainage tiles in the field, and plant row crops.

"Every day, we see more and more land paved over for parking lots, roads, and development. Rain that used to percolate into the ground now becomes a torrent and rips out soil as it flows," he said. "If everyone did what I've done, we wouldn't have this problem."

What Grieves has done is a model for wetland restoration today.

He owns almost 400 acres and put 137 acres into the U.S. Department of Agriculture's Conservation Reserve Program. The program provides landowners with

annual payments. He ripped out the drainage tiles and contoured lakes, ponds, and swales. He planted about 8,000 trees, mostly pecan, walnut, swamp oak, and white oak. He was vice chairman of the Illinois regional board of the Nature Conservancy, and people were watching this transformational process.

Eventually, he took all of his land except about ten acres out of production. He's grown sunflowers on those ten acres and would like to see a local chef or young farmer lease the land for organic vegetable production.

About 1,000 acres of cropland east of his property drain onto the Grieves' land.

"After a three- or four-inch rain, water would roar through here like a freight train," he said.

His work has slowed that torrent.

He built a dam creating a six-acre lake. He has two drainage points and a spillway that feed water into two wetlands. He planted native vegetation and started replicating the hydrology of the land as it used to be. He uses pumps in late summer to draw down the water, emulating the natural pulse of the river. He can pump 7,000 gallons a minute, and he can keep the pumps going day and night.

"I know the way water flows, and I understand the power of water. I put in a series of pipes and designed these wetlands," he said. "You want to slow the water down that drains from the bluffs and allow it to percolate into the ground."

He has both upland bluffs and bottomland on his property. He often leaves the house at 6 a.m. to work on the property and isn't back home until afternoon.

"With that drawdown valve, I can fill these two acres with six inches of water," he said, pointing beyond the path where Sadie was running. "But that lake on the other side is a permanent lake, all gravity fed at that point. Each one of these lakes is different. Three or four are permanent, others are seasonal."

On the seasonal land, he plants vegetation that attracts wildlife.

"We put buckwheat in there. That's a magnet for ducks," he said.

His property includes several sacred Native American sites. He and his grandchildren often find arrowheads and pieces of pottery. There may have once been a tribe of 1,000 Native Americans living on the property.

Looking from his log home down over his wetlands and the Illinois River beyond, Grieves said, "This is the view Native Americans saw from this spot. This beautiful valley is unlike any terrain anywhere in Illinois. My hope is that our grandkids will have a love for the land and take a corner of the world and make it a better place.

"The government can't do this alone. We need individual landowners involved in this work. I'd like to see a necklace of wetlands from Kingston Mines to Havana. That would be a stretch of wetlands forty miles long of protected land along the Illinois River."

Grieves quotes a Native American chief, "The earth does not belong to us. We belong to the earth . . . whatever befalls earth befalls our sons and daughters."

4

JOHN RYAN

Banking on Wetlands

Breezes pungent with the fragrance of moist soil work through the tall grasses at Otter Creek Bend Wetland Park. Towering cattails sway, playing conductor to a concert of frogs, cicadas, finches, and chickadees, occasionally punctuated by the distant scream of a red-tailed hawk.

Paths inside the park twist and turn through territory buffered and secluded by living walls of willows, wild gray dogwood, and chattering cottonwoods. All are sentries, guarding against incursions by the outside world of human civilization raucous with the sounds of cars, trucks, radios, and conversation.

This is an enclave of wordless communication.

Here is a place where children explore nature and feed both their imaginations and their curiosities. It's a meditative place for adults where consciousness of self can slip from being solitary to feeling molecularly connected with the surroundings.

This cellular connectivity possible to experience at Otter Creek Bend is what Ralph Waldo Emerson described when he wrote, "A leaf, a drop, a crystal, a moment of time, is related to the whole and partakes of the perfection of the whole."

On long walks through this wetland, the sense of connection is palpable. This sensation of blending with the surrounding landscape and becoming one with nature is called eutierria, a secular experience causing boundaries between self and nature

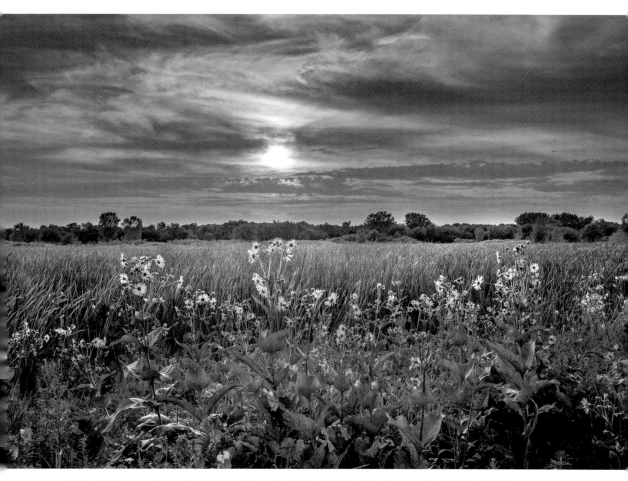

Photo 4.1. The evening sun lowers over Otter Creek Bend Wetland Park, part of the St. Charles Park District. The site is John Ryan's first and favorite project.

to evaporate. It's an enriching, symbiotic experience that creates a sense of harmony and understanding of the interrelationship between humans and the environment.

Nestled in an affluent Chicago suburb, Otter Creek Bend Wetland Park was John Ryan's first wetland restoration. It is a place he still visits frequently for calm reflection after a long, stressful day. It is the place where he has asked his wife to scatter some of his ashes after he dies.

Ryan cut his restoration teeth on this wetland. He learned. He failed. He tweaked and redid. He kept working the concept. After spending years and $600,000 to $700,000 of his own money on this project, Ryan had self-doubts.

That was in the 1990s, and today, the park hosts regular visits by schoolchildren in St. Charles. It functions as part of the Fox River Watershed Restoration and helps cleanse water, soil, and air. People come to detoxify mind and body from technology and worry.

And, significantly, it has monetarily paid for itself thanks to a concept invented by Ryan: the wetland mitigation bank credit system. When developers or the government want to construct roads, buildings, or housing developments in an area identified as a wetland, the environmental impact must be mitigated by credits created by development of a wetland in the same floodplain. Municipalities love development and often push through projects that environmentalists oppose. But with wetland mitigation bank credits, both developers and environmentalists can get behind projects.

"I don't have a lot of competition. This is a challenging goal building high quality wetlands. I am a for-profit company. We make our money from credits. I sell the credits for more than my costs. That's how I stay in business," Ryan said.

Photo 4.2. Residential developers in urban areas experimented with solutions for water runoff management. For many developments, a simple water retention pond suffices. Whether by choice or by edict, a growing number of developers are following John Ryan's lead in wetland mitigation, which offers not only a solution for the water runoff, but a natural aesthetic appeal in an otherwise congested urban landscape.

Photo 4.3. Wetlands in areas of urban development bring the added attraction of recreational benefits.

"The Chicago area is primarily a wet prairie. My background is dirt, but for every wetland, you have to look at the soil type."

Today, there are wetland mitigation banks throughout the country, and Ryan is still working the system. One of his developing projects is outside Gurnee, in the floodplain of the sometimes-raging Des Plaines River.

The temperature and humidity were already climbing by 10 a.m. on a summer morning, and Ryan's face was dripping with perspiration as he rigged two wire fences to block access to one of his sites to keep people from dumping trash on it.

His enthusiasm was undiminished by the broken drywall, plastic buckets, tires, and garbage bags that had been tossed on the access roads to the property.

People don't recognize a valuable transition is underway on this property. To an uninformed eye, the acreage looks neglected, no precise rows of corn and soybeans, no neatly maintained fencerows. There's a clear-cut strip of scrub timber and lots of bare dirt.

But Ryan is clearly excited when he points out infinitesimally tiny grasses emerging from the soil. They are the results of a planting two weeks earlier of native prairie seeds on this land that had once been pasture for livestock, then, more recently, was planted in row crops.

Ryan can see what most passersby can't. This is the start of a metamorphosis.

"The public drives by a wetland restoration like this and it looks like a field of weeds," he said. "The public does not understand what these sites do."

Ryan bought this land in order to take it out of agricultural production and coax it into wetland and high prairie. The goal of the farmer who owned the land had been the opposite—to drain water from the fields as quickly as possible, channeling it through a series of clay tile tubes buried below ground. Ryan ripped out the tiles and wants the water to pool on the land to allow deep-rooted prairie plants to soak it up.

A self-described "dirt man," Ryan was the fourth generation in Ryan Inc., founded in the 1880s by Ryan's great-grandfather who moved dirt with mule teams. Today, the company is one of the largest earthmoving firms in the world.

But Ryan became increasingly frustrated by delayed permits, concerns over the environmental impact of development, and multiple interpretations of construction codes. He studied the Clean Water Act of 1972, and he remembers waking up one night in 1990 with a solution: "a wetland mitigation bank credit."

Ryan became so involved with wetland mitigation banking that he sold his shares in the family business and started Land and Water Resources Inc., based in Rosemont, Illinois. Most of his work is now in the Chicago area, but he's done projects across the country.

His father, who had mentored him to step into the family business (even sending him to a surveying course at University of Wisconsin when he was nine years old), watched his son move away from earthmoving for huge development projects and start working with native grasses, hydrology, and swampland.

"My father was on his deathbed after a lifetime of earthmoving, and he said to me, 'John, I never knew it was a sin to destroy wetlands. You have to make up for all my sins.' Dad died ten years ago," Ryan said. "He was extremely proud of what I was doing."

The work is not without frustration—from cleaning up illegally dumped trash and dealing with irate people at town hall meetings to working through ponderous bureaucracies.

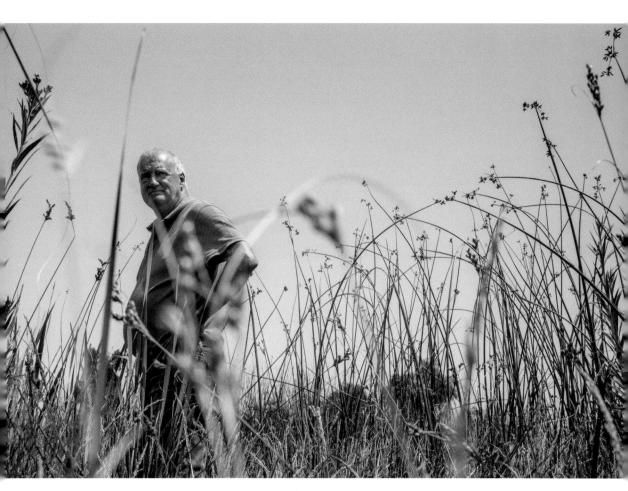

Photo 4.4. John Ryan pauses during a walk through a wetland he developed and recalls neighboring residents' fears "the swamp" would diminish the value of the neighborhood. As seasons progressed and flora and fauna thrived, fear gave way to pride. Ryan then gave the property to the township of Libertyville along with an endowment fund for maintenance.

Sometimes, neighbors living near one of his projects don't understand the ultimate beauty. When scrub trees are cut down, they complain. When fields look weedy, they complain. But when native vegetation takes hold after about three years, neighbors begin to see the aesthetic miracle unfolding. When fields are blanketed with migrating waterfowl, neighbors are spellbound. And when they learn these projects can result in up to a forty percent increase in nearby property values, they become advocates.

Ryan once received a blistering letter from an official with the Audubon Society complaining about one of his developing wetlands, but three years into the disputed

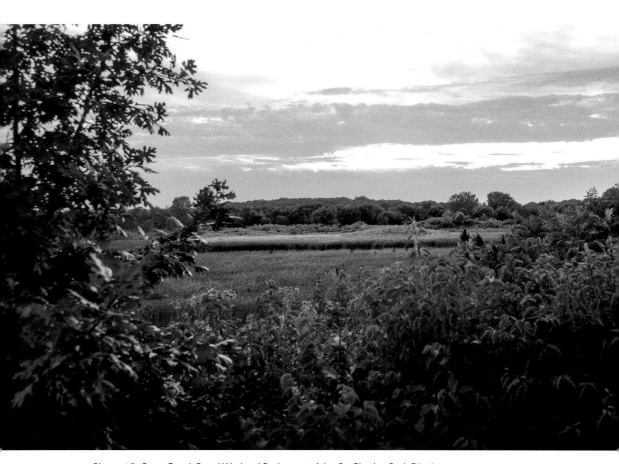

Photo 4.5. Otter Creek Bend Wetland Park, part of the St. Charles Park District.

project, that person called to say he'd witnessed thousands of shorebirds at the site and now understood the vision.

"The more people learn about wetland restoration, the more they realize their old understandings may be wrong," he said.

The Clean Water Act showed Ryan a way to shift restoration work from the realm of philanthropists, conservation groups, and individual landowners to an industry based on the currency of credits in wetland mitigation banks.

As a pioneer of the concept in 1990, Ryan has fought through much of the skepticism and anger.

In his first mitigation bank, Otter Creek Bend Wetland Park, he invested nearly $700,000 and worked for four years before he was able to earn any income by selling credits. He remembers thinking, "'Oh my god, I've invested thousands of dollars in

native seeds and wasted it.' I didn't know anything about prairie plants back then and didn't know it takes years for them to take over a site."

Recently, he was approached by the Illinois Department of Transportation asking to buy all his credits. He was able to sell them $7.4 million in credits and later learned they had budgeted $10 million.

"I couldn't have come up with $10 million. My entire inventory came to $7.4 million," he said.

Ryan testified in Congress multiple times, met innumerable times with the U.S. Army Corps of Engineers, Illinois Department of Transportation, municipalities, neighborhood associations, and others. One of his most memorable meetings occurred after he had testified at a Senate hearing and was leaving the Capitol Building. He was approached by officials who told him someone wanted to meet with him, but they were not at liberty to discuss who that was.

Ryan was escorted to an empty room. He was annoyed, skeptical, and then astounded when then-Vice President Al Gore walked into the room. They talked about the Clean Water Act and Ryan's work restoring wetlands.

But Gore had one overarching question: How was Ryan able to garner support from both developers and environmentalists?

"I can explain," Ryan said, launching into a discussion of wetland mitigation banks that make projects easier for developers, cut their permitting time by half while at the same time satisfying environmentalists who want compensatory wetlands of equal or greater environmental value to counterbalance any wetlands destroyed by construction of highways or developments.

One of his favorite sites is eighty acres that includes the headwater of the Chicago River. After the project was completed, he gave the site to the township of Libertyville. There is no taxing line item for this property, and all costs for maintenance are covered by Ryan. The restoration was fought by neighbors. They complained when he cut scrub buckthorn trees. There are now 150 varieties of native wetland plants and special protected status for a grove of ancient oaks that before this restoration could have been cleared for housing projects.

"I love this site. I really enjoy the giant green rush and the nutsedge growing here," he said looking out on the wetland. "And there's a snowy egret!"

Despite wilting July heat, the wetland grasses swayed in a breeze and looked vibrantly green and healthy.

"Wetland mitigation banking is a way to do well and do good. There is no other career with the complexity of wetland restoration," he said.

The work involves knowledge of construction, sales, finance, hydrology, environmentalism, wildlife, and vegetation. It takes patience and a long-term perspective.

Ryan has completed more than thirty wetland restoration banks. Before the establishment of wetland mitigation banks, granting permits and denying permits seemed arbitrary at times and often stretched out for years, costing developers time and money. Now mitigation banking is the preferred method and it's based on science.

At one time, when wetlands were viewed as unproductive swampland, bulldozing over them posed no problem. Builders were often given carte blanche permission by communities eager to enhance property tax revenues. However, bulldozing and paving over wetlands destroys the environment's natural sponge-like ability to absorb huge quantities of water. That causes increasing flooding downstream resulting in billions of dollars of damage paid for by governments, private insurance companies, and individuals.

"I like thinking that this work is helping the environment," Ryan said. "And that it will continue after me. This will be my legacy."

5

MAYOR KRISTINA KOVARIK

Watching, Waiting, and Worrying

Water surging down the Des Plaines River in 2007 sent the village of Gurnee into a frenzy. The community of 30,000 in the Chicago metropolitan area knew the drill. Emergency warnings. Arduous sand bagging. Evacuations. Uncertainty. Watching, waiting, and worrying.

But the waiting stretched on and on with residents dealing with frayed nerves and emotional exhaustion. Finally, the village administrator went up in a helicopter to fly over the path of the river and try to accurately gauge when disaster would hit.

What he saw stunned him.

The raging storm surge barreling down on Gurnee had been diverted over acres and acres of restored wetlands. The destructive force of the flooded river was transformed into a gentle backwater. Native bowfin, bluegill, and shad darted through longleaf pondweed in the shallow waters, and tussock sedge grew atop the banks.

This land had once been planted in corn and soybeans, saturated with farm chemicals, and forced into total exhaustion.

The transformation was otherworldly.

Back in Gurnee, Mayor Kristina Kovarik spoke with the media and reported on the remarkable observation. Disaster averted!

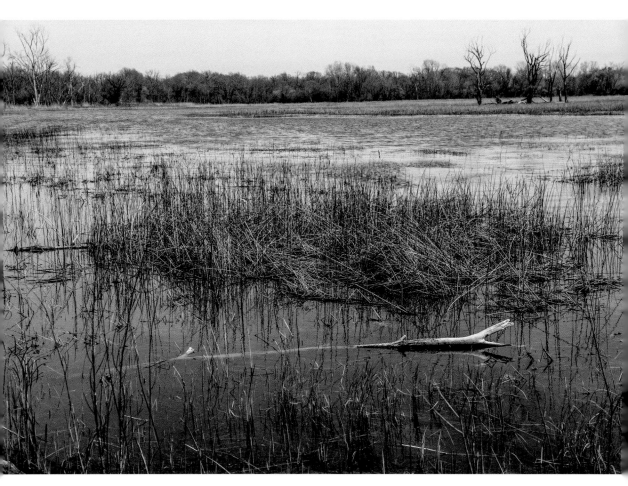

Photo 5.1. The wetland along the Des Plaines River near Wadsworth, north of Gurnee, has helped alleviate some of the flooding consequences historically plaguing Gurnee and other communities along the tributary.

Next day, she received a phone call.

"Those are my wetlands," the caller told her.

That was the start of a professional relationship between the mayor of Gurnee and Donald Hey, executive director and co-founder of Wetlands Research in Wadsworth.

"Those wetlands were like a giant sponge, a giant shock absorber for us," the mayor said. "We can't control the river. Mother Nature is more powerful than anything we try to do. Just look at history and understand pumps, dams, and dikes do not work."

Flooding is now the most expensive and common natural disaster in the United States. From 1980 to 2013, flooding cost Americans more than $260 billion in

damages, according to the National Centers for Environmental Information. In 2016, the federal government declared thirty-six natural disasters involving floods or hurricanes. Four of those storms each exceeded $1 billion in damages. Costs are expected to increase exponentially as the number of historic floods increases.

Mitigation work can cost billions and involve massive projects with concrete and steel. Another option that costs far less involves strategic planning of parks, prairie, and wetland restoration.

Interestingly, the expensive mitigation projects are based primarily on engineering, while the less expensive restoration projects often involve environmentalism, ecology, social justice, art, and philosophy.

Mayor Kovarik said some of the flooding in Gurnee broke her heart when she spoke with families who lost their homes. She understands the emotional costs to those families.

"It's heartbreaking. Heartbreaking," she said. "When forty percent of our property owners experienced devastating losses and couldn't get into their homes, you cry with them."

Her career in banking and mortgage lending gave Kovarik an edge in grasping the economics and cost-benefit analysis of wetlands.

Photo 5.2. Gurnee mayor Kristina Kovarik relays the dread of an anticipated storm surge on the Des Plaines River in 2007. Village officials, who had for decades battled the flooding river with traditional sandbagging and other methods, discovered the flood surge had dispersed into wetlands upriver.

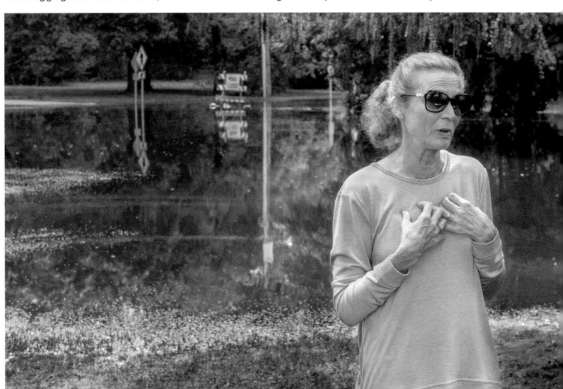

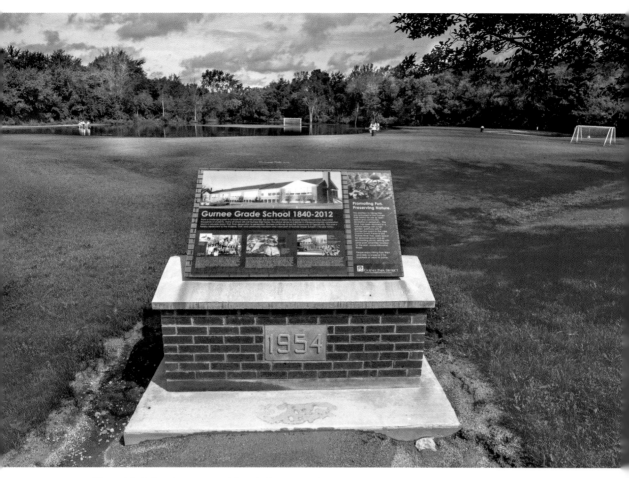

Photo 5.3. Following repeated floods that swept through the elementary school in Gurnee, village residents passed a referendum to build a school at a new location and raze the old school, returning the land to its historic role in a floodplain.

"The most cost-effective way to mitigate flood damage is to get out of the way," she said. "Figure out where the river wants to go and accommodate it."

Kovarik became a village trustee in 1999 and worked on a flood mitigation committee in 2001 that released a study assessing the cost of flood insurance, managing stormwater in the village, and mapping buildings in the floodplain.

The study sat on a shelf in the village hall for the next four years until she became mayor in 2005 and started implementing the plan.

Using matching funds from the Federal Emergency Management Agency (FEMA), the village received seventy-five percent of the cost and provided twenty-five percent of the cost to buy homes and businesses in the floodplain, tearing the structures

down, and leaving the land undeveloped in parkland. The plan started with two or three properties a year and was completely voluntary on the part of property owners.

When the flood in 2007 swept through the elementary school, the mayor asked then-Illinois senator Mark Kirk for help relocating the school. Voters approved a referendum to build a new school and the federal government helped raze the old structure, essentially returning the property to the historic floodplain of the Des Plaines River.

"By the time the flood of 2013 hit, we began to see the fruits of our labor," Kovarik said. "Fewer structures are affected; people are protected; our costs are down."

The flood of 1986 was historic for Gurnee until the flood of 2017 hit. That flood was an unprecedented combination of river flooding and the torrential rains now associated with climate change.

But by 2017, Kovarik was well along with the plan moving the most vulnerable properties in the village out of the path of the Des Plaines River.

Before the town started moving, flooding caused damage when the river crested at seven feet. By 2017, damage was averted until the crest hit nine feet. In 1986, the river rose one foot an hour. By 2017, the river rose one foot in four hours. Those two feet and extra hours meant the difference for many people between losing homes and personal family possessions and coming through a historic flood with relatively minor damage.

"When you understand the power of the water, you understand you can't contain it," Kovarik said. "The flood of '86 was historic . . . until the flood of 2017."

The mayor likes to say simply, "I understand the power of water."

She also understands that with 700 rivers feeding into the Mississippi River, what she and her village do to keep water in wetlands affects everyone downstream. She wishes the work she's doing would also be embraced by communities upstream in Wisconsin.

"I wish Wisconsin would work on wetland restoration," she said. "I'm not a liberal environmentalist, but I can see the force of the river. Everyone in the United States is affected one way or another with this issue. Rising insurance costs result in higher premiums for everyone. Disaster relief raises everyone's taxes."

After studying and working on flood mitigation for decades, Kovarik laughed with frustration when her own husband suggested the village elevate and reconstruct a major roadway that is regularly closed due to flooding.

"No," she said. "Look at the cost-benefit analysis! There's not an adequate return on that investment."

Working alongside Kovarik is village engineer David Ziegler.

"She is the most proactive city mayor I know working on flood reduction," Ziegler said. "Every year that we continue to buy and raze properties, we lessen the impact future floods have on our community. We work our plan year after year, understanding there can always be a bigger flood, and we plan for that. The problem of flooding is never going to get smaller; it will only get bigger. Public policy needs to address the social burden of hundred-year floods that can now happen every five years."

Ziegler said as an engineer, he knows how to think critically.

"In dealing with disasters, we can't follow the same process to get the same answer. We can't view sandbagging year after year as a solution. We have to perceive the problem differently to get to a different solution," he said.

Smiling in agreement with that statement is Donald Hey, the man who designed the wetland north of Gurnee along the Des Plaines River.

Hey has designed more than half a dozen wetland restorations in the Chicago area. As he watches flooding grow in cost and devastation year after year, he rethinks and redesigns his concepts. One of his first wetland restorations is internationally recognized: the 3,000-acre Sue and Wes Dixon Waterfowl Refuge outside Hennepin, Illinois, about one hundred miles southwest of Chicago.

Hey discusses his most ambitious project yet in chapter 6.

6

DONALD HEY

A Riverine National Park System Financed by Nutrient Farming

Donald Hey is a pioneer, scientist, hydrologist, ecologist, environmentalist, and idea man with a passionate commitment to wetland restoration. He's always the advance man, the point man pursuing the next frontier of wetland research.

It can be a lonely position. Once he completes a project and works out the inevitable kinks, he's on to something bigger and more challenging.

"Donald was always one step ahead of the rest of us," said Doug Blodgett, who now oversees wetland restoration at the Nature Conservancy's Emiquon Preserve site in central Illinois.

After conceptualizing and funding a dozen wetland restorations throughout the Midwest and consulting on scores more, Hey has a new vision: the Riverine National Park System.

Like America's protected National Park System, Hey is proposing a multistate system with thousands of acres of wetlands strategically placed to interact beautifully and effectively with massive flooding that now sweeps across the nation almost annually with historic volumes of water and accompanying damage.

While many scientists develop a commitment to wetland restoration from their interest in waterfowl hunting, Hey arrived at his vocation and avocation from pure science.

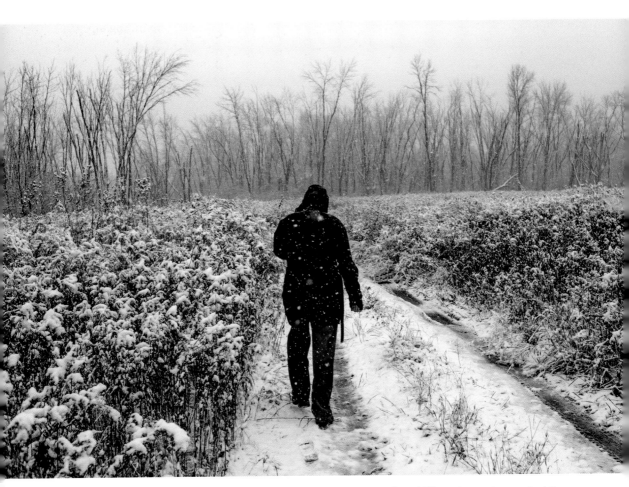

Photo 6.1. Wetlands Research co-founder and executive director Donald Hey takes a phone call while walking in an early spring snow shower at a wetland he designed near Wadsworth, Illinois.

He is so immersed in the evolution of wetlands that he speaks of turbidity, bowfin, hydrating floodplains, and riffles as though everyone is familiar with his lexicon.

After working on the establishment of the Sue and Wes Dixon Waterfowl Refuge south of Chicago, Hey co-founded Wetlands Research in Wadsworth, northwest of Chicago. He oversaw the acquisition of a sixty-acre site along the Des Plaines River and designed a riffle system using large rocks to build stone steps across the river. The $350,000 cost included design, permitting, and construction of the riffles.

That riffle system controls 200 square miles of watershed. After eighteen months, a thirteen-mile section of the once muddy Des Plaines River became clear enough so native fish, notably bowfin, are able to see and eat invasive Asian carp. Hey says

that's a better solution to invasive carp than electric shocks that end up killing all fish, both native and invasive.

His riffle system diverted enough floodwater roaring into Illinois from Wisconsin in 2007 that the village of Gurnee was spared millions of dollars in flood damage.

But Hey wants everyone to understand that the value of wetland restoration goes beyond flood control.

Water flowing into the wetland can be measured for pollutants and nitrogen. After filtering through a system of native vegetation and backwaters, water flowing out the other end of the wetland can be measured again and reduction of pollutants can be calibrated.

Like the wetland mitigation bank concept developed by John Ryan (chapter 4), Hey would like credits awarded for reduction in nitrogen and other pollutants, including farm chemicals and pharmaceuticals that are ubiquitous in rivers and streams. He calls this nutrient farming.

Filtering and removing nitrogen in the wetland means less nitrogen downstream contributing to the dead zone in the Gulf of Mexico. Removing pollutants through nutrient farming is less costly than dealing with damage downstream.

Photo 6.2. Donald Hey, co-founder of Wetlands Research in Wadsworth, Illinois, stands on a riffle system he designed as part of a sixty-acre restoration along the Des Plaines River, northwest of Chicago. Hey devised the riffle across the river to slow water velocity.

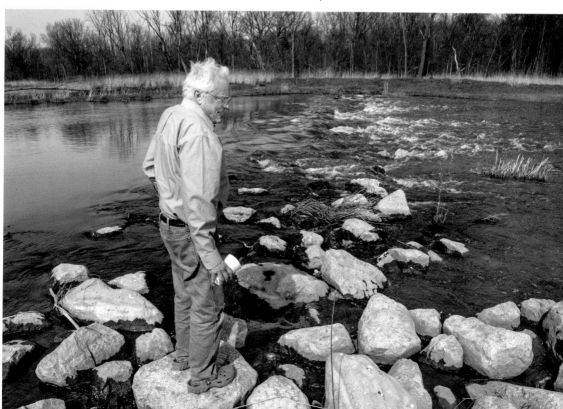

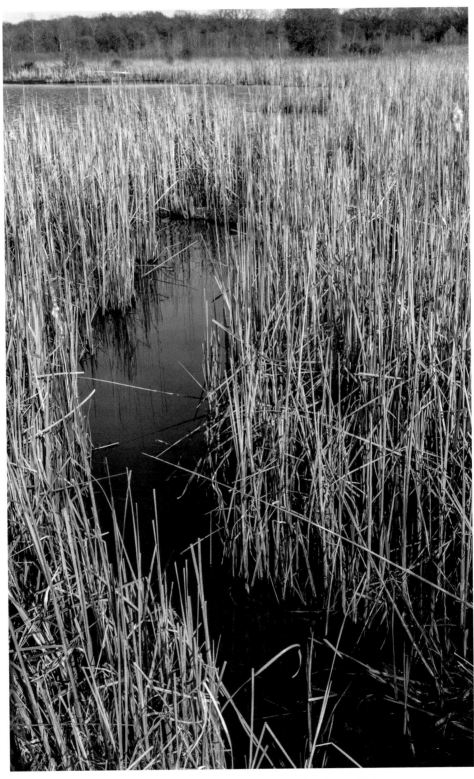

Photo 6.3. Animal activity leaves a trail through reeds in a wetland park near Wadsworth.

According to his calculations, the economic benefit for farmers with floodplain wetlands could greatly exceed the economic return they receive from row crop production of corn and soybeans.

If his concept of cost-benefit analysis could be calculated, the Riverine National Park System would pay for itself without any state or federal funding, Hey contends. Theoretically, farmers could sell credits, earning about $300 an acre. That would reduce the uncertainty inherent in farming and dramatically reduce government costs for crop insurance.

With that source of monetary income, he would expect to see wetland restorations take off throughout Illinois, Iowa, Missouri, Wisconsin, and Minnesota, and he envisions that network of wetlands as the Riverine National Park System.

As communities grow, parking lots expand, and mayors advocate for development, water runoff becomes an increasing environmental disaster.

"Development threatens good storm water management in this country," Hey said. "Many communities still rely on storm water management that was in place before World War II. Rivers and streams become agricultural sewers."

There is no mandate for water quality and quantity currently running off farm fields. The government's agriculture policy rewards productivity, not enhancing water quality. Rather than slowing water down and filtering out chemical pollutants through wetlands, farmers continue to install tiling systems with underground pipes. Meandering streams that slow water flow can be channelized so water is flushed off the land.

Convincing people the system needs to change is a Herculean task.

Although Hey is all about the science, he has a personal explanation for his lifetime of determined focus. His family lived in Kansas when he was growing up, and his father suffered a debilitating stroke when Hey was ten years old. Although his father lost all speech and could not walk, Hey's mother brought him home from the hospital and reorganized their lives. She was a nurse and took a job on the night shift at a local nursing home so she could be home with her disabled husband during the day while her children were in school. At night, the children were there to help and assist.

After college, Hey left for the Peace Corps with his mother's blessings. One month after he returned home from the Peace Corps, his father died. He had been bedridden and cared for at home for fifteen years. Hey said that taught him the value of focused determination.

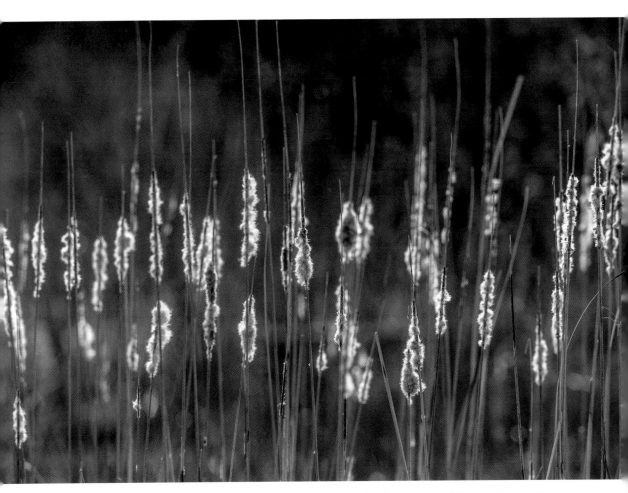

Photo 6.4. Late afternoon sunlight highlights cattails in a wetland park north of Wadsworth along the Des Plaines River.

Now in his late seventies, Hey continues to meet with politicians and government leaders to garner support for the Riverine National Park System. He confers with scientists and continues his own research.

"No, not discouraging," Hey insisted. "Each step along the way, you find someone special who sees the problem and understands the solution."

7

DOUG BLODGETT

A Huge Cattle Feedlot Becomes an
Internationally Acclaimed Wetland

Depending on the year and the water level, drive south on Illinois Route 78, crest a hill, and Emiquon Preserve opens before you like a vast inland sea—an utter impossibility, an illusion, an oasis in a shimmering landscape of corn and soybeans.

Depending on the season, the sky above Emiquon can be equally implausible, filled with a swirling, undulating mass of pelicans, ducks, and geese.

Emiquon is a process of thinking as much as a physical place.

The facts of this place: The Nature Conservancy purchased about 7,000 acres of farmland in 2000. This land had originally been a wetland connected to the Illinois River. But in the early 1900s, dikes and levees were built and water was pumped out. Corn, soybeans, and cattle were raised on the property. In 2007, the Nature Conservancy turned off the pumps.

Nearby, the U.S. Fish and Wildlife Service owns and manages about 3,000 acres. Dickson Mounds State Museum sits on the edge of the wetland. The remains of hundreds of Native Americans are interred in sacred burial mounds on the property. These locations work in partnership, providing a glimpse into Earth's past. As the vast sea that once covered the planet slowly receded, swamps, wetlands, marshes, mud flats, and bogs emerged as incubators for the first amphibians.

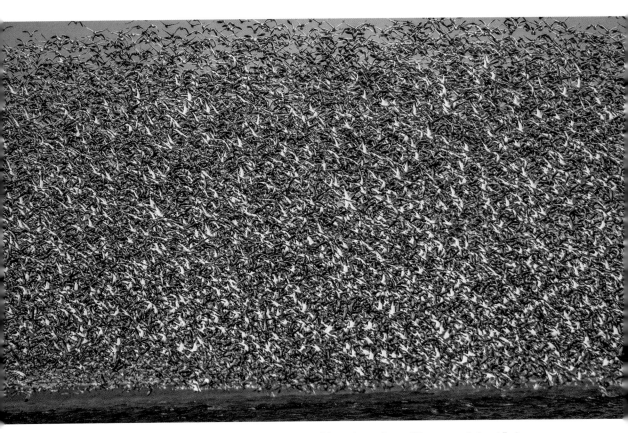

Photo 7.1. Tens of thousands of snow geese lift off from the surface of Thompson Lake at Emiquon Preserve. Once one of the largest cattle feedlots in the nation, the land was part of a 7,000-acre purchase in 2000 by the Nature Conservancy.

The process of thinking about this place is infinitely more complicated and conflicted: from a rich and fertile wetland hunted and fished by Native American people, to a relentless march from small family farms and duck hunting clubs, to formation of a water district with dikes, levees, and pumps. Corporate ownership sold to a global conglomerate. Business decisions were based on the commerce of quarterly earnings, not fertility of an ecosystem or the sacred heritage of a people.

Using that metric for value, it's easy to understand how one of the largest cattle feedlots in the nation operated on the property, turning out 8,000 head of cattle annually.

Today, Emiquon is moving backwards, back to its natural role in the ecosystem and back to honoring this sacred site for Native American ancestors as well as a resting spot and safe haven for migratory waterfowl.

Photo 7.2. As the waters of Thompson Lake at Emiquon Preserve recede with a controlled drawdown of the water level, the concrete foundation of what was once one of the largest cattle feed operations in the country reveals itself.

Photo 7.3. A fisherman moves across the surface of Thompson Lake at Emiquon Preserve.

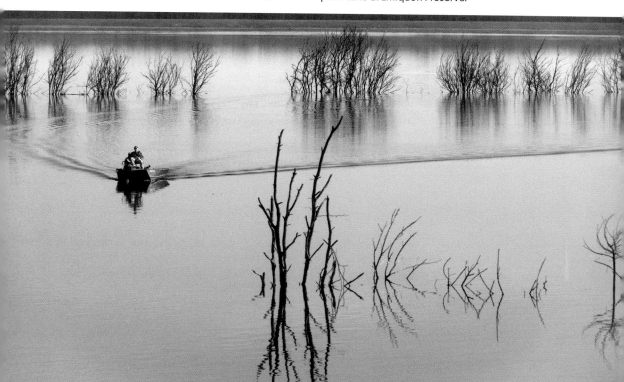

Photo 7.4. Doug Blodgett, director of river conservation at the Nature Conservancy based at Emiquon, drives along the edge of Thompson Lake.

Value at Emiquon also can be measured in recreational terms with public fishing, hunting, birding, hiking, and boating on the property.

Value can also be measured in environmental terms. It is one of the largest restored wetlands in the nation.

The Emiquon restoration was designed to remain cut off from the Illinois River. Scientists wanted to keep out contaminants, sediment, and invasive species.

"Wetland restoration must happen. We can't afford to continue to eliminate wetlands," said Doug Blodgett, director of river conservation for the Illinois Chapter of the Nature Conservancy based at Emiquon. "By the 1920s, half of the floodplain along the Illinois River had been leveed. Chicago sewage was dumped into the river."

Concern over Chicago sewage roiled for years. In the late 1800s, the city was dumping sewage into Lake Michigan. The lake was also the city's water source. To deal with that sanitation issue, the Sanitary District of Chicago, now the Metropolitan Water Reclamation District of Greater Chicago, reversed the flow of the Chicago River and started dumping sewage into the Des Plaines and Illinois Rivers rather than Lake Michigan.

Over the past century, regulations mandate stricter sewage treatment. However, during heavy rain, Chicago and Peoria and dozens of other cities still experience storm sewer overflows and raw sewage is dumped into rivers.

This history is all part of the Emiquon story. The property is a massive, interactive science lab. In 2017, a $6 million research structure and gateway between the wetland and the river opened. It allows scientists to drain water from Emiquon into the Illinois River. Prior to that, water levels had remained too high to mimic the cyclical nature of wetlands.

Photo 7.5. Doug Blodgett, director of river conservation at the Nature Conservancy based at Emiquon, leads a tour of the gateway introduced in 2017 between the Illinois River and the wetland. The device allows scientists to drain water from the wetland to replicate the natural seasonal cycle of the wetland's ebb and flow.

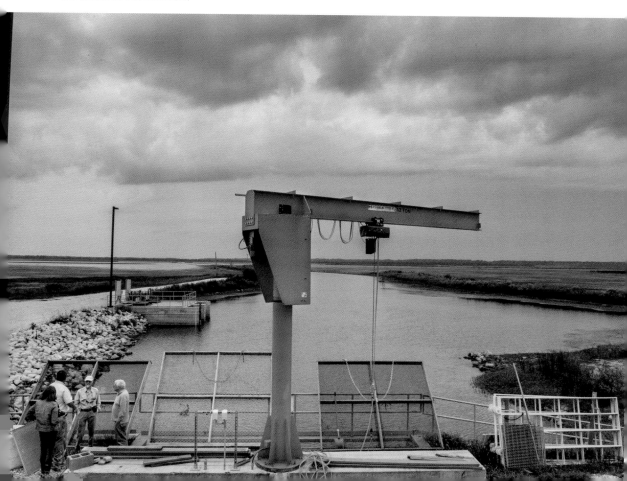

Blodgett said the research structure is unique in the world and attracts scientists from many countries as more nations struggle to find ways to mitigate flooding and restore wetlands.

"This building is like the Superconducting Super Collider. It's a learning and research model," Blodgett said. "Wetlands have the most economic value of any natural habitat. They pay for themselves with flood control and upgrades to sewage systems. They sequester nitrogen and create wildlife habitat."

Emiquon is like an injection of adrenaline into field research. On a glorious September morning, researchers Christopher Hine and Abby Blake-Bradshaw, with the Illinois Natural History Survey, steered their airboat across the wetland, stopping at various locations mapping aquatic vegetation.

An airboat traveling at thirty miles an hour feels like a car going seventy miles an hour.

Hine said wetland vegetation thrives when the environment goes from wet to dry periods. Originally, Emiquon was performing more like a reservoir than a wetland when water levels stayed high year after year.

Photo 7.6. Abby Blake-Bradshaw steers the airboat she and fellow researcher Christopher Hine use to traverse the waters of Emiquon Preserve during their research of aquatic plant life for the Illinois Natural History Survey.

Photo 7.7. Illinois Natural History Survey researcher Abby Blake-Bradshaw leans over the side of an airboat and gathers aquatic plants as part of a study of the health of the environment at Emiquon Preserve. Blake-Bradshaw and fellow researcher Christopher Hine study sago pondweed, coontail, American lotus, and invasive Eurasian water milfoil.

"What we don't understand, we don't appreciate. The more we have learned, the more work there is to do," Hine said.

"What was one of the largest feedlot operations in the country is now an internationally recognized Ramsar wetland [accredited by the Ramsar Convention on Wetlands based in Ramsar, Iran] and known to birders and environmentalists around the world."

The two scientists steered the airboat to specific colonies of plants, monitoring sago pondweed, coontail, American lotus, and invasive Eurasian water milfoil. They steered the boat past cormorant nests as coots scooted across the surface of the water out of the boat's path and great egrets flew overhead.

"We might spend ten days in the field and four to six weeks analyzing the data we collect," Hine said.

A lot of local people were against taking this land out of agriculture and restoring the wetland, he said.

Even though the Nature Conservancy is a not-for-profit organization, it has volunteered to continue paying property taxes on the land so there is no negative financial impact on local government.

"The biggest concern in the Illinois River valley is changing hydrology of the river. Historically, it was predictable," Hine said. "Now it's very erratic—whether due to climate change or urban sprawl. It's like trying to read an EKG."

Scientists at Emiquon are working to understand and reestablish the natural pulse of the river that breathed life into wetlands for thousands of years.

Photo 7.8. Coots flee the arrival of an evening visitor to Thompson Lake at Emiquon Preserve.

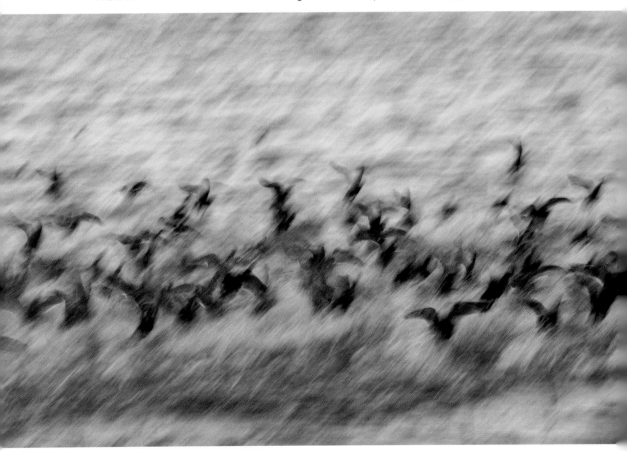

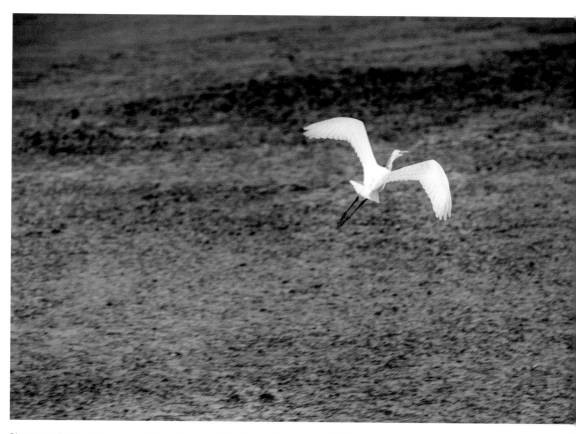

Photo 7.9. An American egret takes wing over the Nature Conservancy's Emiquon Preserve.

Photo 7.10. American white pelicans plunge their heads beneath the surface of Thompson Lake at Emiquon Preserve.

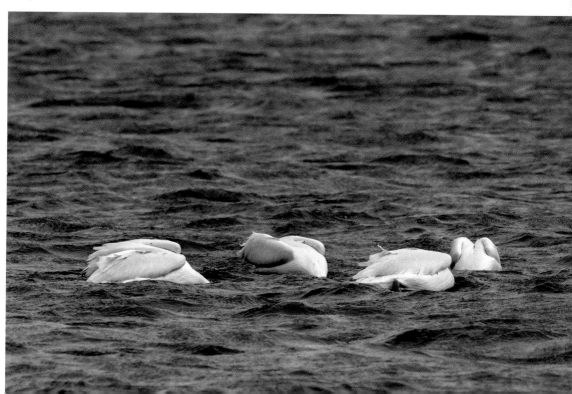

Photo 7.11. Thompson Lake at Emiquon Preserve.

8

DOUG AND DIANE OBERHELMAN

From "Hell With the Fires Put Out" to Quail Lakes Wetland Sanctuary

The temperature hovered at eighteen degrees as the first pearly-gray light of dawn crept over a snowy landscape. No sunrise inflamed the eastern horizon. The line between land and sky blended seamlessly and almost indistinguishably save for a few boundaries defined by distant tree lines.

The Midwest, famous for its expansive sky, projected an aura of infinity this morning—360 degrees of pearly gray in all directions. Losing visual cues creates a slight disorientation and lures a person walking over this icy terrain to listen beyond what is audible and peer beyond what is visible, stretching the senses so thin the environment seeps in to fill the spaces.

Two solitary hikers walking across a landscape isolated from any other trace of human activity remove time and place from consciousness of self.

It's a sensation often referred to as becoming one with nature, creating a bond with nature, and intuitively understanding our connection to nature.

This is the sensation of eutierria, a secular experience of harmony and connection with the natural world and the cosmos. The experience heightens understanding of our dependence and connection with the environment.

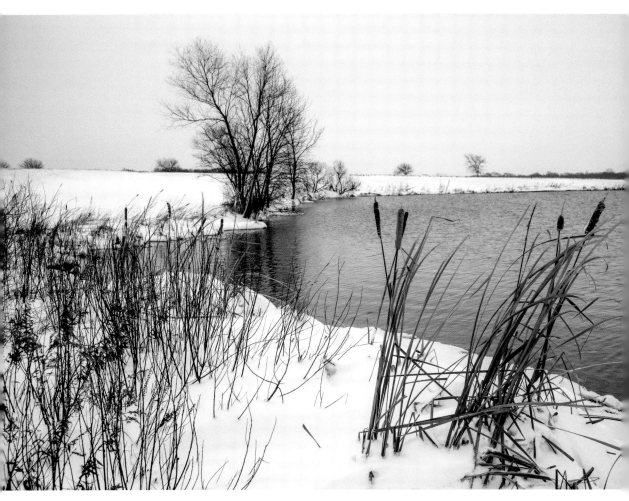

Photo 8.1. Cattails edge a snowy lake favored by geese and ducks at Quail Lakes, a wetland restoration site. A former strip mine, Quail Lakes is now a series of water-filled pits, some as deep as seventy-five feet, with contoured land in between covered in grasslands and fields of sunflowers.

Quail Lakes strengthens that bond. But it was not always so. What preceded Quail Lakes wetland sanctuary was near-total destruction with the land viewed only as a resource to harvest, even if that meant creating a barren moonscape once referred to as looking like "hell with the fires put out."

That was the legacy of strip mining for coal. Today, the 1,200-acre tract known as Quail Lakes is the legacy of landowners Doug and Diane Oberhelman and the Surface Mining Control and Reclamation Act.

An examination of the history of this region shows that few areas of the world have undergone such transformation and such redemption.

Quail Lakes is privately owned land west of Peoria. This region of west central Illinois was inhabited by Paleo-Indians at the end of the Ice Age. As the climate warmed and vegetation changed, Woodland and Mississippian people lived in the area. The Illiniwek Confederation included a dozen Native American tribes. In the 1700s, tribes moving to the region included these familiar names: Fox, Ioway, Kickapoo, Peoria, Potawatomi, and Winnebago. There were oak and hickory forests, tall-grass prairie, and rich backwater lakes teaming with fish and wildlife.

Early European explorers viewed central Illinois with eyes trained by the dense forests, mountains and lakes of their homelands. They saw the necklace of shallow backwater lakes pocketing much of the region as wasteland, marshes, and swamps. They saw the Illinois River as flawed because it was not deep enough for commercial transportation between Chicago and St. Louis. Prairie was featureless, boundless, and intimidating—a vast and lonely landscape. But perhaps the biggest sin was these resources were "unproductive."

It was with that flawed understanding of the ecology that white Europeans in the 1800s first settled the region around Quail Lakes. The land was logged and cultivated. On wet fields, drainage tiles were installed to get water off the land and into drainage ditches trenched at the edges of fields. Farmers needed enough moisture so crops could grow but not the amount of water in fields that were really ephemeral wetlands unsuited for agriculture. Those fields were forced into row crop production against their will.

Small underground coal mines pocketed the area.

Following the Black Hawk War in 1832, Native Americans were expelled from Illinois and ordered to go west.

Change around Quail Lakes and the Midwest accelerated in 1837 when John Deere invented the steel plow. Prior to that, plows were made of wood or iron. The soft, sticky soils of the Midwest clung to the plow and slowed tillage. But with the steel plow, settlers were able to slice through thick prairie roots, some more than fifteen feet deep, and cultivate soil that rapidly became known as some of the finest in the world.

In 1878, the Illinois General Assembly authorized creation of drainage districts with taxing power. Farmers with adjacent swampland could join together to dike their land, operate pumps around the clock, year-round, and share in a special tax to maintain the operation.

It proved profitable by one metric even though it failed to recognize and calibrate environmental costs.

Surface mining for coal became widespread in the 1930s. The process is referred to as strip mining. It was cheaper and safer than underground mining. Companies often relied on massive equipment produced by Caterpillar Inc. to clear all vegetation and topsoil and extract rich veins of coal. There was no concern initially with land reclamation.

Between 1976 and 1984, the property known today as Quail Lakes was strip mined by Midland Coal Co. Surface pits were as deep as seventy-five feet.

But in 1977, Congress passed the Surface Mining Control and Reclamation Act. It was signed by President Jimmy Carter.

Midland and other coal companies had to restore the land after they had exhausted coal veins. The land was graded, contoured, and topsoil was replaced.

The owners of Quail Lakes bring their own history and perspective to land management and reclamation. Doug Oberhelman is a former CEO of Caterpillar Inc., the manufacturing giant that developed some of the equipment once used on strip mines on the Quail Lakes property. Diane Oberhelman is founder and CEO of a national development company.

Photo 8.2. Doug and Diane Oberhelman enjoy showing visitors the former strip mine they are restoring to a natural Midwest landscape.

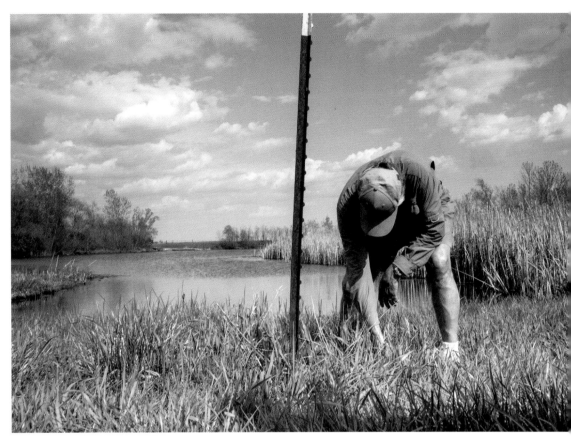

Photo 8.3. Doug Oberhelman reaches for the control mechanism that can move water to or from one of a series of lakes he and his wife, Diane, are restoring in Peoria County.

They are dedicated to land conservation and manage tracts of deep-rooted prairie, use cover crops, construct dry dams and terraces to slow the flow of water. Zero erosion on 1,200 acres is their formidable goal. They use manure on their property from an adjacent dairy operation. Their land is in agriculture production and wildlife habitat. There are two deep lakes on the property, half a dozen ponds, and wildlife in abundance.

Quail Lakes proves that resources can be responsibly extracted from the earth, Doug Oberhelman said.

The balance between agricultural yields, clean energy, and conservation is critical, but commercial production often shouts its message, while the environment whispers, quietly asserting its vital role. During hikes at Quail Lakes, it's easier to hear those whispers.

The reclamation here under the guidance of the Oberhelmans started when Doug Oberhelman returned to central Illinois after working in Japan for Caterpillar Inc. He wanted someplace to get away and de-stress from demands at work. He looked for a patch of land where he could hunt and hike. If land can be anthropomorphized, Oberhelman's Quail Lakes acreage was a depleted old woman after giving birth for decades to corn, soybeans, timber, and coal with little love in return. She was seriously eroding. Oberhelman and his wife hunted the land and fished in the deep pits formed from strip mining.

They learned the history of the land dating back thousands of years when Native Americans hunted and used stone hoes to dig the earth. Doug Oberhelman credits the Surface Mining Control and Reclamation Act for restoring responsible land use. The deep pits remaining from the mining operation fill with water and become magnets for waterfowl and wildlife.

"Land restoration is a rich man's game," Oberhelman said as he recounted the decades of work put into this property.

Quail Lakes is accessed off Peabody Road, a nod to a history of reconciliation and restoration. A nod to the property's future: The couple's four children and eleven grandchildren are steeped in this land ethic.

Photo 8.4. Thousands of tons of coal were once mined from this site.

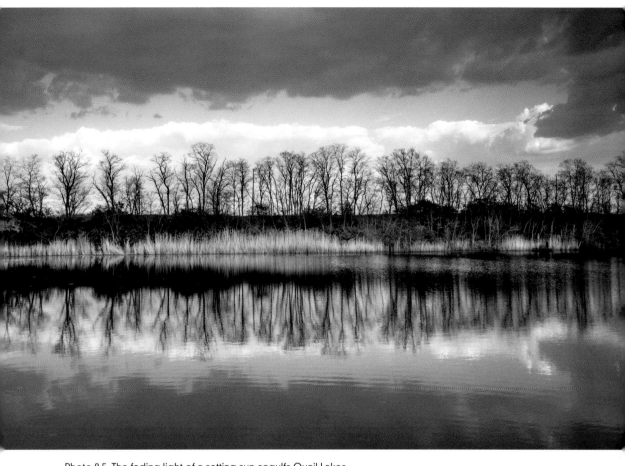

Photo 8.5. The fading light of a setting sun engulfs Quail Lakes.

9

JOHN FRANKLIN AND JIM FULTON

Invisible Harvest

JOHN FRANKLIN

This is a tale of two farm fields.

There is the Midwest farm field devoid of sound—silent like a soundproof chamber. Monarch butterflies and green darner dragonflies feel unwelcomed here. Crops harvested from these fields can be quantified and monetized. Yields are calculated as bushels per acre, and futures contracts are closely watched on the Chicago Board of Trade. Coffee shop conversations evolve around seed performance and pesticide resistance.

But just down the road is a field yielding an invisible harvest. There are no commodity exchanges, no combines, and no storage bins for the harvest from this land. This field is owned by a family of farmer-environmentalists.

The property explodes with the sounds of seasonal concerts. In early spring, a sweet percussion of tree frogs trills into the night. By June, chorus frogs sit in the string section, producing the sound of a thumb running across a comb. Crickets join in as accompaniment. On the cusp of the long, hot days of summer, bullfrogs slide into position on the bass drum. Almost as a reminder that autumn will inevitably approach, cicadas start their nocturnal arias.

Photo 9.1. A green darner dragonfly dips onto the water surface to lay its eggs at John Franklin's constructed wetland on his McLean County farm.

But these concerts are collateral. The real goal is invisible and inaudible, not fanciful but strategic.

This is acreage managed by wetland nutrient farming pioneers. They are in the forefront of a growing land ethic. They shoulder responsibility for the growing hypoxia zone in the Gulf of Mexico. They recognize fertilizer that flushes off their land following heavy rain contributes to the dead zone and to dying coral reefs, algae blooms, and other often unmeasured and unrecognized negative consequences. They respect what is known and unknown.

These ag pioneers oversee constructed wetlands. They have tucked some of these constructed wetlands into the corners of corn and soybean fields, while

others are strung like pearls in grassy waterways meandering across fields. Some look like farm ponds with water current flowing from end to end, while others are irregular with current deliberately slowed to zigzag, snake, and meander toward the outlet.

Constructed wetlands represent new thinking in farm country and run counter to the well-established practice of getting standing water off farm fields as fast as possible. Standing water delays spring planting and kills emerging plants. Many farmers have pipes called tiles buried under their fields. Field tiles are designed to drain water off a field like a bathtub with an open drain. Many of these tiles were installed more than a century ago. Installation of new tiles continues to this day. It's a regular phenomenon that can be witnessed throughout the countryside.

"Two spades deep and two spades wide" is how John Franklin's father described the depth and width of field tiles. Digging by hand has been replaced with installation by equipment. But some farmers are digging out tiles rather than installing them.

Photo 9.2. McLean County farmer John Franklin, whose land is included in the aerial photograph on the wall behind him, talks of his lifelong interest in the environment that brought him to experiment with constructed wetlands on his farm.

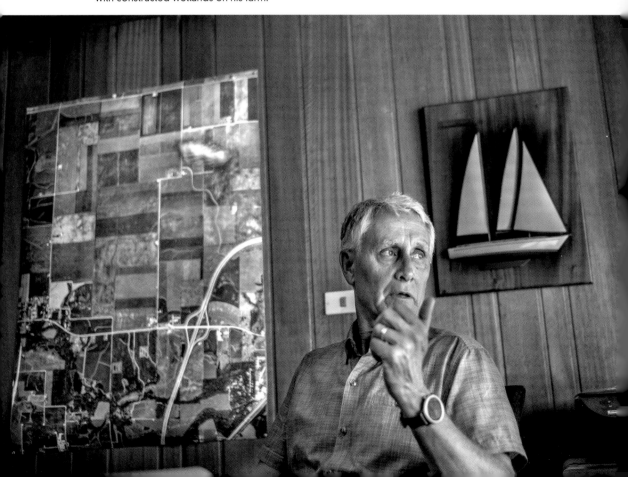

Photo 9.3. Cattle on John Franklin's farm now graze amid purple coneflowers, compass plants, and shooting stars in fields adjacent to constructed wetlands.

The Franklin farm outside Lexington in McLean County is now in the fifth generation of family ownership and reflects that new thinking.

"My father would have loved this," said Franklin, sixty.

His father loved the land and practiced a land ethic widely believed at the time, but as a Cornell University graduate, his father embraced new learning.

Cattle on the farm now graze in restored prairies with purple coneflowers, compass plants, and shooting stars—looking like a Midwest version of Ferdinand, the bull who would rather smell wildflowers than fight.

West of these grazed wildflower meadows on the Franklin farm are a series of constructed wetlands that drain water from land planted in corn and soybeans.

Today, the farm covers about 770 acres with ownership shared by ten to twelve family members. Everyone was on board with the idea of taking several acres out of crop production for constructed wetlands.

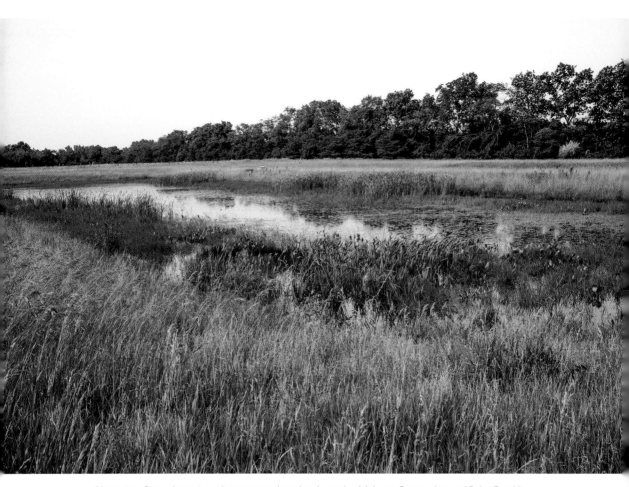

Photo 9.4. One of a series of constructed wetlands on the McLean County farm of John Franklin.

"We all grew up at the start of the environmental movement. That was the movement of our youth," said Franklin. Another factor helping the decision to install constructed wetlands is that no one in the family derives his or her sole income from the farm.

"There has to be a balance between profit and environmentalism. These constructed wetlands can go on marginal land," Franklin said.

His wetland flows into Turkey Creek.

Growing up in the area, Franklin recalls Turkey Creek with fairly low banks. He has photos of Turkey Creek in the 1940s with virtually no banks. Today, the creek banks are eight-feet high, carved by the force of channelized water.

Photo 9.5. Maria Lemke, aquatic ecologist with the Nature Conservancy, checks equipment on John Franklin's farm that will allow monitoring levels of chemicals flowing to the wetlands and comparing the figures to amounts in the outflow.

"The volume of water running through tiles off fields literally scours out the creek banks," Franklin said, acknowledging that his family's decision to install constructed wetlands likely was influenced by 150 years of ownership and a sense of land stewardship projecting another 150 years into the future.

He credits the Clean Water Act as among the best government regulations and blames fertilizer running off farm fields in the Midwest for the dead zone in the Gulf of Mexico. A section of the Conservation Reserve Program in the Farm Bill covers constructed wetlands. The government pays for part of the construction costs and part can be reimbursed with grants.

"Farmers and the fertilizer industry realize we have to solve this problem before the government mandates a solution," Franklin said.

Working closely with Franklin on the wetlands is Maria Lemke, an aquatic ecologist with the Nature Conservancy.

"We now have enough data to prove this is a viable concept" to construct wetlands to filter out nutrient runoff, Lemke said.

What is now needed is to work out the ratio between wetland size and amount of tiled row crop land that drains into the wetlands.

The Nature Conservancy has been working in this area that drains into the Mackinaw River for a quarter of a century.

"The Mackinaw is a beautiful river with a great forest riparian buffer and lots of biodiversity," Lemke said. "Seeing field tiles installed used to be disturbing to me. Now I focus on how to get ahead of that problem. There are so many pieces of the puzzle still to be worked out."

She is attuned to the struggle new farmers face and realizes she's asking for a paradigm change.

"But now when I start talking about the link to the dead zone in the Gulf of Mexico, people get that," she said.

Conclusion: Nutrient farming pioneers are part of ongoing research into finding a balance between farming for profit and environmentalism. Creating wetlands on sections of farm fields is emerging science that potentially can mitigate hundreds of hypoxia, dead zones in oceans around the world.

Photo 9.6. Jill Kostel, senior environmental engineer with the Wetlands Initiative, converses with Jim Fulton in Livingston County, where she oversees Fulton's constructed wetland project.

JIM FULTON

On a farm thirty miles to the northeast of the Franklin farm is another wetland pioneer nutrient farmer. Growing up in the same era that gave birth to the environmental movement is Jim Fulton, sixty-three, a fifth-generation farmer outside Saunemin in Livingston County.

Fulton derives all his income from his farm operation, but when he was approached by the Wetlands Initiative, a not-for-profit based in Chicago, he was open to the notion of taking a few acres out of production for a constructed wetland.

Fulton speaks the language of commodity crops: bushels per acre, super weeds, grass waterways, soil compaction, buffer zones, and drainage tiles. But there is also the Jim Fulton who plants trees, and when his children were young, he helped with their 4-H projects, collecting leaves from fifty different species of trees all from their own property. There is the Jim Fulton who watches for the monarch butterfly migration. His wife, Ruth Ann, maintains a pollinator garden that attracts butterflies, and each year, their children were sent to school with a chrysalis that the class would watch, anxiously awaiting the emergence of a monarch butterfly.

Photo 9.7. Jim Fulton's constructed wetland sits in the vast landscape of row crops in Livingston County.

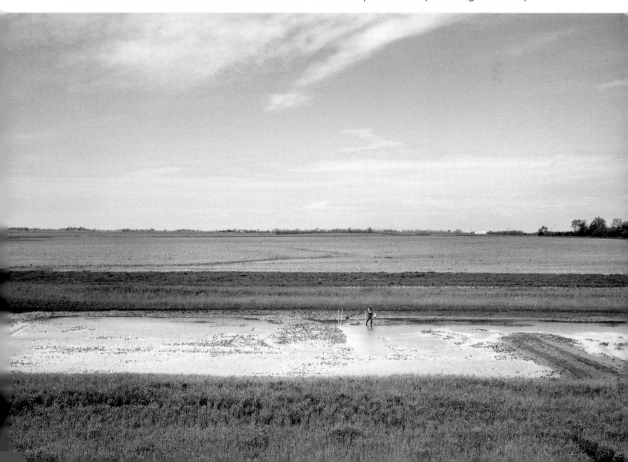

Fulton knows well that in farming, margins are tight with unknowns beyond weather, including turmoil in world commodity prices, tariffs, and embargoes. Farmers look for ever-increasing productivity.

But this year, Fulton is measuring productivity on some of his 690 acres with a new, nontangible harvest. He is taking acreage out of conventional production and putting it into "nutrient farming."

Nutrient farming is not a monetized crop—at least not yet. The harvest is real, but it's invisible. The yield is a global benefit thousands of miles from Fulton's farm.

Normally, Fulton works with a four- or five-year rotation for corn, soybeans, oats, alfalfa, and wheat. But this year, he's taking one corner of a field out of row crop production altogether. There will be zero bushels per acre on these 4.6 acres.

Measurements from these acres are part of an emerging science: constructed wetland nutrient farming. Nitrogen from fertilizers is the main harvested nutrient, but others include phosphorous and agricultural chemicals. Harvested, in this case, means filtered out of the water by vegetation.

The project cost Fulton about $60,000, but most of that was recouped with grants. However, he's taking an annual loss on commodity crops that were previously harvested off these acres.

His annual opportunity cost could be measured this way:

These 4.6 acres could be planted in soybeans selling at nine dollars a bushel. With average yields of fifty bushels per acre, that would be gross sales of $2,070. The land is committed to wetlands for fifteen years so that comes to $31,050.

Fulton is convinced this is the right thing to do.

His collaborating partner, the Chicago-based Wetlands Initiative, has designed and installed the pond surrounded by native deep-rooted vegetation.

Jill Kostel, senior environmental engineer with the Wetlands Initiative, oversees the Fulton project. She literally shares that oversight with Fulton's black Lab Bert, who greets everyone walking onto the property, examines all moved soil, and repeatedly spreads all four legs and submerges his belly into the mud at the bottom of each section of the pond.

"All my duct tape has dog hair in it," Kostel said as Bert squeezes in closely, watching as she tapes marker flags around the wetland.

Kostel said farmers are concerned about nitrogen runoff both in terms of contaminating drinking water and as a major contributor to the hypoxia zones in the oceans.

Photo 9.8. Jim Fulton's black Lab Bert watches as Jill Kostel, senior environmental engineer with the Wetlands Initiative, sets marker flags around the wetland.

"If the farm sector can get ahead of this problem, it could avoid regulatory controls," she said. "When the landowner sees the installation, it can be a little intimidating, but once this is established, up, and running, there is no maintenance."

Paul Botts, president and executive director of the Wetlands Initiative, said, "A wetland, properly sculpted, can do miraculous jobs. We are at the stage of gathering proof of that concept. We'd like to see this become a normal practice in the farm belt. Our vision is someday we'll see maybe 10,000 small wetlands."

Water from Fulton's farm and his neighbors' farmland drains through a buffer strip of deep-rooted prairie plants, into the pond, and out into Five Mile Creek. Kostel and other scientists from the Wetlands Initiative will measure the water running

into the pond for nitrogen running off the fields. The water will be measured again after passing through the wetland as it enters the creek. Five Mile Creek runs into the Vermilion River that runs into the Illinois River, running into the Mississippi River, and ultimately into the Gulf of Mexico.

The transformation of Fulton's acreage was a major family event watched carefully by his son, who lives at home, and by his daughter and grandchildren, who drove over from their home in Indiana. The public was invited.

Everyone took pictures of massive earthmoving equipment digging more than 6,000 cubic yards of soil, contouring the terrain, and replacing the topsoil.

Over the course of a week, equipment on the site included five excavators, three bulldozers, one skid steer, a big scraper, a trencher, a sheep's foot roller, and a four-wheel John Deere tractor.

Water began to fill the pond that had been shaped in a snake-like undulation to slow down the current from one end to the other.

Photo 9.9. Jim Fulton reviews a PowerPoint at the United Methodist Church in Saunemin that he presented during construction of his wetland to inform his neighbors of the project and its importance in the stewardship of his land and water.

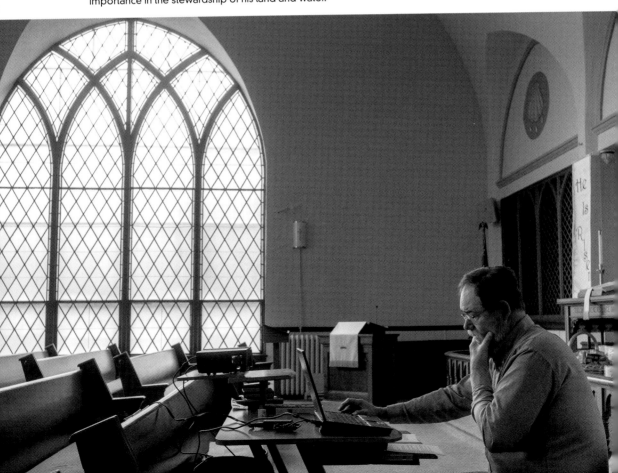

Photo 9.10. Facing the mud in the wetland under construction on Jim Fulton's Livingston County farm, the Wetlands Initiative's Rick Seibert dons waders before walking into the water to throw seeds.

Fulton combined the pictures with a narrative and gave a PowerPoint presentation to the congregation at the United Methodist Church in Saunemin, where he and his family attend.

Asked why the PowerPoint at church, his simple answer is "stewardship."

"This is one of the most cost-effective ways to reduce nitrogen runoff," Fulton said.

His PowerPoint opens with a history of the farm started by his great-grandfather with the purchase of 480 acres in 1893. Descendants inherited portions, added land, and swapped land.

"My point to all this is that I did nothing to own this land. I inherited it and have been given the responsibility to take care of it and to make it prosper," said Fulton. "My goal is to leave it better than it was when I took it over and then to pass it on to the next generation."

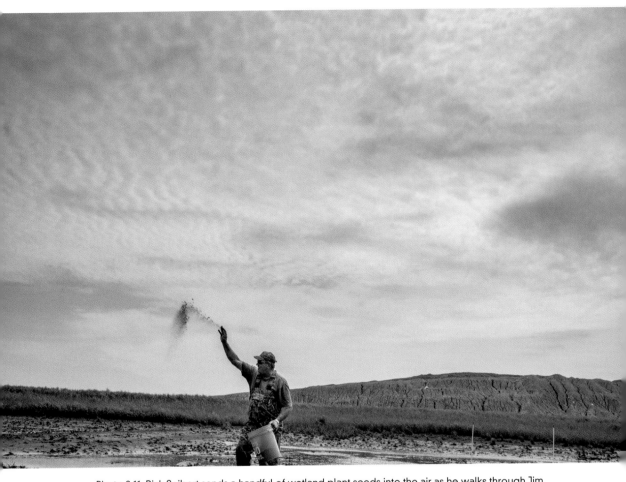

Photo 9.11. Rick Seibert sends a handful of wetland plant seeds into the air as he walks through Jim Fulton's constructed wetland in Livingston County.

10

MIKE MILLER AND JIM KLEINWACHTER

An Army of Wetland Advocates

MIKE MILLER

His dry, technical title is supervisor of environmental and interpretive services for the Peoria Park District. His professional profile could include naturalist, environmentalist, biologist, ornithologist, entomologist, and botanist. But Mike Miller's skill set includes poet, writer, philosopher, photographer, teacher, and urban planner.

He's remarkably ambidextrous in right-brain-left-brain thinking.

For him, wetland restoration is not just a process of science and environmentalism; it's a spiritual connection to the environment. He contends wetland restoration is not just a hobby for wealthy landowners, not-for-profit organizations, and farmers trying to limit their environmental harm. It is for everyone.

His goal is to build an environmental army with a visceral connection to the earth. His approach is to draw in people from all socio-economic levels, all cultures, and nationalities.

"We are at a fork in the road in terms of our ability to shape our destiny," Miller said. "We need to develop a language that is depolarizing."

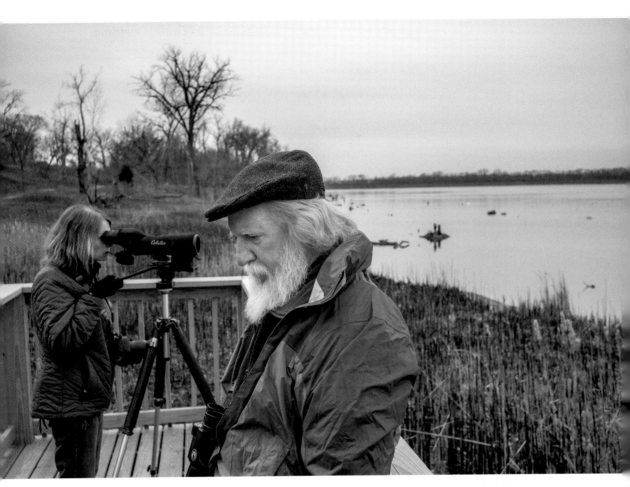

Photo 10.1. Peoria Audubon Society conservation chairman Mike Miller and his wife, Cyndi, pause on an observation platform at Sue and Wes Dixon Waterfowl Refuge at Hennepin and Hopper Lakes near Hennepin.

Every property owner can create a bioswale or rain garden, Miller said. Deep-rooted perennials should be part of every homeowner's landscape. Inner city lots can become sites for urban agriculture, bioswales, and pollinator habitats.

He is critical of public policy that looks at urban sewers and storm systems through the lens of money and concrete infrastructure. He wants to build spiritual and cultural connections to the environment that shape the way people think and act.

When more homeowners think in terms of their own individual power to help the environment, an army of advocates forms. Rather than more engineers and accountants looking at solutions, we need more poets and artists, Miller said.

"One of the most important tools in the environmentalist's toolbox is something that is very human—art," he said. "By its definition, the arts connect with people at very personal and visceral levels."

He credits *Silent Spring* by Rachel Carson as an example of literature that launched the environmental movement.

"Simply put, she penned a clarion call to action. If we don't change our ways and keep dumping synthetic pesticides into the environment, there will come a spring when there will be no bird song," said Miller, conservation chairman and past president of Peoria Audubon Society. "It was science that gave her the facts, but it was the art of literature that captured the culture."

JIM KLEINWACHTER

The art of bioswales, deep-rooted perennials, wetlands, and green roofs is the lexicon used at the Conservation Foundation in Naperville.

Jim Kleinwachter, manager of the home program at the Conservation Foundation, could be called the army recruiter.

He thinks of his job as building bridges between scientists, conservationists, and homeowners.

Kleinwachter gives about sixty presentations a year recruiting for a green army. He speaks at civic organizations, municipalities, homeowner associations, and park districts.

"I don't only want to sell fifty rain barrels; I want to change thought patterns," he said.

His office at the Conservation Foundation headquarters is the site of a historic farm in Naperville that was left to the organization by Lenore Clow McDonald. A conservation easement means the organization can continue to use the land for agriculture, education, and conservation, even as housing developments crop up around it. There are demonstration gardens, wetlands, bioswales, rain barrels, a green roof, permeable concrete, solar panels, a wind turbine, a 25,000-gallon rainwater harvesting system, and sustainably farmed fields. The organization sells its harvest through a CSA, a community-supported agriculture program. Members pay for a season of produce and pick up their share on a weekly basis. The CSA provides food for 500 families.

"We are on a sixty-acre site and water does not leave our property," Kleinwachter said.

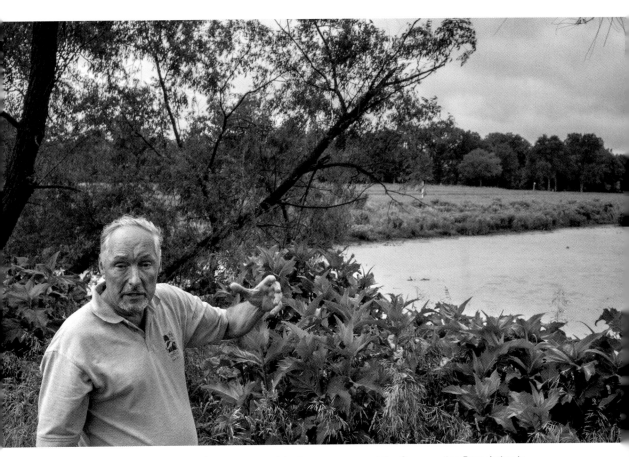

Photo 10.2. Jim Kleinwachter, manager of the home program at the Conservation Foundation in Naperville, stands by one of a series of wetlands on the property surrounded by urban development.

In the 1950s, a nearby creek was diverted into a drainage pipe. To correct that, the foundation worked with consultants and had the pipe removed, and water was directed into a series of three wetlands. Water enters the property loaded with nitrogen and other chemicals. It passes through the first wetland and enters the second pond with less pollution. The final pond has water clean enough for fish.

Part of Kleinwachter's mission is to convince people to switch from strictly ornamental plants to the workhorses of the environment—native plants.

"A hosta just sits in the garden inert. Roses and lilacs are not native," he said. "I'm not telling people to tear out all their turf and lilacs but to mix the decorative plants with functional plants. Prairie dropseed absorbs tons of water. We want more native species and more diversity."

Kleinwachter does extensive outreach with municipalities.

"We work with communities to change public policies," he said.

Photo 10.3. A rain barrel used at the Conservation Foundation in Naperville serves as just one example of simple actions homeowners can undertake to stem the flow of water from their properties.

When a homeowner calls DuPage County in anger, frustration, and exasperation over flooding, the call is often forwarded to Kleinwachter.

He arranges a home visit with his toolbox of environmental knowledge, communication skills, and enthusiasm.

"I advise the homeowner about rain barrels and rain gardens. I give them a list of native plants. We invite them to our property to see turf alternatives and our pollinator meadow," he said. "We can recommend contractors to help them do the work."

Some property owners in the suburbs complain about problems with geese in their bioswales and ponds.

"Geese like mowed edges around ponds. They like turf lawn up to the water edge," he said. "We can solve that problem with a border of deep-rooted perennials. That's ecologically sound and it solves the goose problem and the mowing problem."

Instead of mowing once a week, these borders are mowed once a year.

Photo 10.4. A rain garden demonstrates how to control water runoff in urban areas and add beauty at the same time at the Conservation Foundation in Naperville.

"The cost is fifty percent less to maintain a wildflower border than turf," he said.

Kleinwachter measures success one yard at a time, even one plant at a time.

"It's pretty easy to sell the idea that the earth is in bad shape, and these small changes can help," he said.

Everyone, including property owners, renters, and schoolchildren, can have a voice in public policy decisions concerning wetlands, bioswales, and stormwater management. Resources are available through park districts and conservation organizations to help people learn to see solutions not in concrete but in native vegetation.

For more information about native plants, rain gardens, and best management practices, visit the Conservation Foundation's website at www.theconservationfoundation.org.

EPILOGUE

We came to this topic through our work as newspaper journalists. At its best, journalism is a process of research presenting multiple perspectives and dimensions. At its best, journalism enhances levels of understanding. It is neither a process of stenography nor is it the repeated presentation of visual stereotypes.

In our work for the newspaper, we met some remarkable people who were restoring and developing wetlands, and we set out to find others working in this field.

Our research for the book started with a focus on the science, but we're not scientists. We did not want to write a textbook on wetlands. After working on this project for almost a year, we shifted our focus to people. It was then the science and the spirit of wetlands percolated onto the pages.

Just as each wetland is different, so are the people who work on them. Yet they all went through a similar process of mental calisthenics going from the known to the unknown. That was not an abstract transition but one with financial and emotional costs. Several of them spoke of the anger and ridicule directed at them for embarking on this process of wetland restoration and wetland construction. Despite the challenges, they continued. Even with years of education, training, and experience, they were still open to trying something that flies in the face of best past practices. They were able to compile new levels of understanding and knowledge.

One example of the "anti-knowledge" effect is experts and authorities who are challenged by new thinking, are unable to recognize their own lack of knowledge, and are blinded by the time they spent accumulating their knowledge.

John Dewey called this coating the mind "with varnish waterproof to new ideas."

That kind of criticism was directed at John Ryan (chapter 4); he received a blistering letter from an official of the Audubon Society at the start of one of his wetland restoration projects. It was three years into the evolution of the project before the official called Ryan with praise. He saw the wetland was functioning, restoring the natural flow of water, and attracting migrating birds.

Defying entrenched beliefs requires courage. We have enormous respect and admiration for the people featured in this book. They shared their stories and their time without reservation. It became clear their mission was not only restoring and constructing wetlands but freely sharing hard-earned knowledge.

They gave us the opportunity to skim across the surface of Emiquon Preserve in an airboat and listen as two scientists mapped growth of sago pondweed; to hear and feel the roar of 250,000 snow geese lifting off the surface of a lake; to experience the disorientation of eutierria as we hiked across a snow-covered wetland that blended seamlessly into a pearl-gray sky at dawn—blotting all sense of up and down, self and environment.

It is our hope the information and images presented in this book can change the way people view the environment. Instead of seeing a field of weeds or an ugly swamp, people embody this information and use it to shape their own perceptions and levels of understanding and perhaps even become advocates of the beauty and spirit of wetlands.

GLOSSARY

Bioswales: depressions in the topography where rainwater accumulates and is absorbed into the soil by deep-rooted plants. The purpose of a bioswale is to prevent water runoff and erosion. Bioswales, also called rain gardens, can be natural or constructed.

Drainage tiles or field tiles: pipes installed in fields to quickly drain water from the land to prevent damage to crops. The tiles were clay at one time but are now primarily plastic conduits. The widespread use of this drainage system has enabled wetlands and ephemeral wetlands to be planted in agricultural crops. The system has caused serious environmental damage, erosion, and nutrient runoff from farm fields.

Duck Spotter: a guide often employed by duck hunting clubs to take members to locations most likely to have large numbers of migrating waterfowl.

Eutierria: a secular, meditative experience that can occur in nature when boundaries between self and the environment seem to evaporate—creating a sense of oneness with the natural world.

Nutrient farming: a system that measures chemicals in water flowing into a wetland and those in water flowing out of the wetland after it has passed through vegetation designed to absorb nitrogen, phosphorous, and other chemical pollutants. Scientist Donald Hey would like to see a monetary payment given for the reduction of farm chemicals and other pollutants removed from the water through a system something like the U.S. Department of Agriculture's Conservation Reserve Program.

Nutrient runoff: comprised of nitrogen, phosphorous, and other agricultural fertilizers that are not absorbed by corn, soybeans, wheat, and other crops. It runs off fields in rainwater and then flushes fertilizer into streams, lakes, and rivers and eventually into oceans, causing hypoxia or dead zones.

Row-crop production: a system of planting crops in rows wide enough for agricultural machinery. Corn, soybeans, and wheat are examples of row crops.

Seventh generation thinking: a Native American belief for evaluating the benefit or harm of a decision based on the possible impact it will have on seven generations into the future.

Shelf cloud: a cloud formation that appears like a dense blanket advancing across the sky. It can be dramatic and heralds the approach of heavy wind and rain. It can bring a pungent aroma of approaching rain.

U.S. Department of Agriculture's Conservation Reserve Program: a land conservation program that pays property owners to remove marginal land from agricultural production and plant it in trees, grasses, and other vegetation that can reduce runoff and improve the environment.

CLARE HOWARD is a journalist formerly at the *Peoria Journal Star* and *Scholastic Teacher*. She is a member of the Society of Environmental Journalists.

DAVID ZALAZNIK is a photojournalist formerly at the *Peoria Journal Star* and the *Lincoln Courier*. He is the author of *Life along the Illinois River*.

The University of Illinois Press
is a founding member of the
Association of University Presses.

Text designed by Jennifer S. Fisher
Composed in 10.5/16 Weidemann Std
with DIN 30640 Std display
by Jennifer S. Fisher
at the University of Illinois Press
Manufactured by Versa Press

University of Illinois Press
1325 South Oak Street
Champaign, IL 61820-6903
www.press.uillinois.edu